MARY
CASSATT

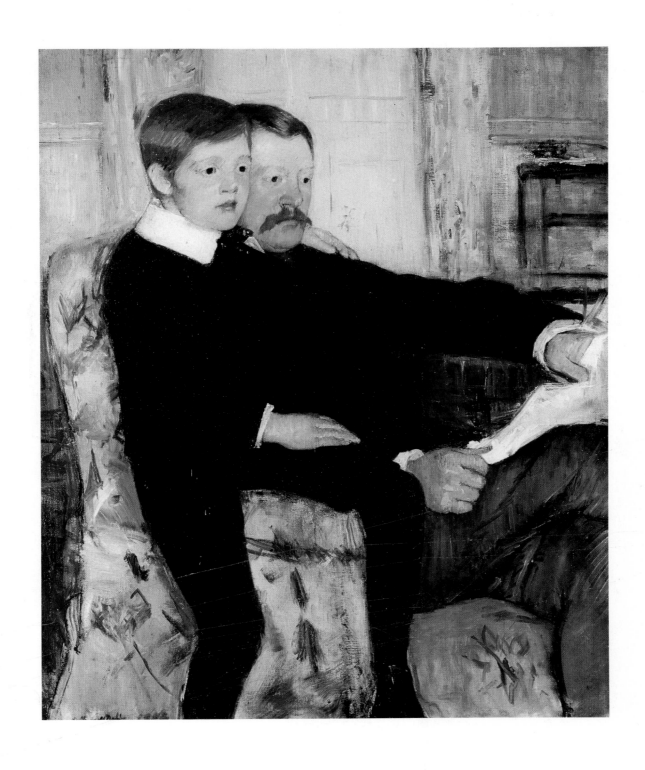

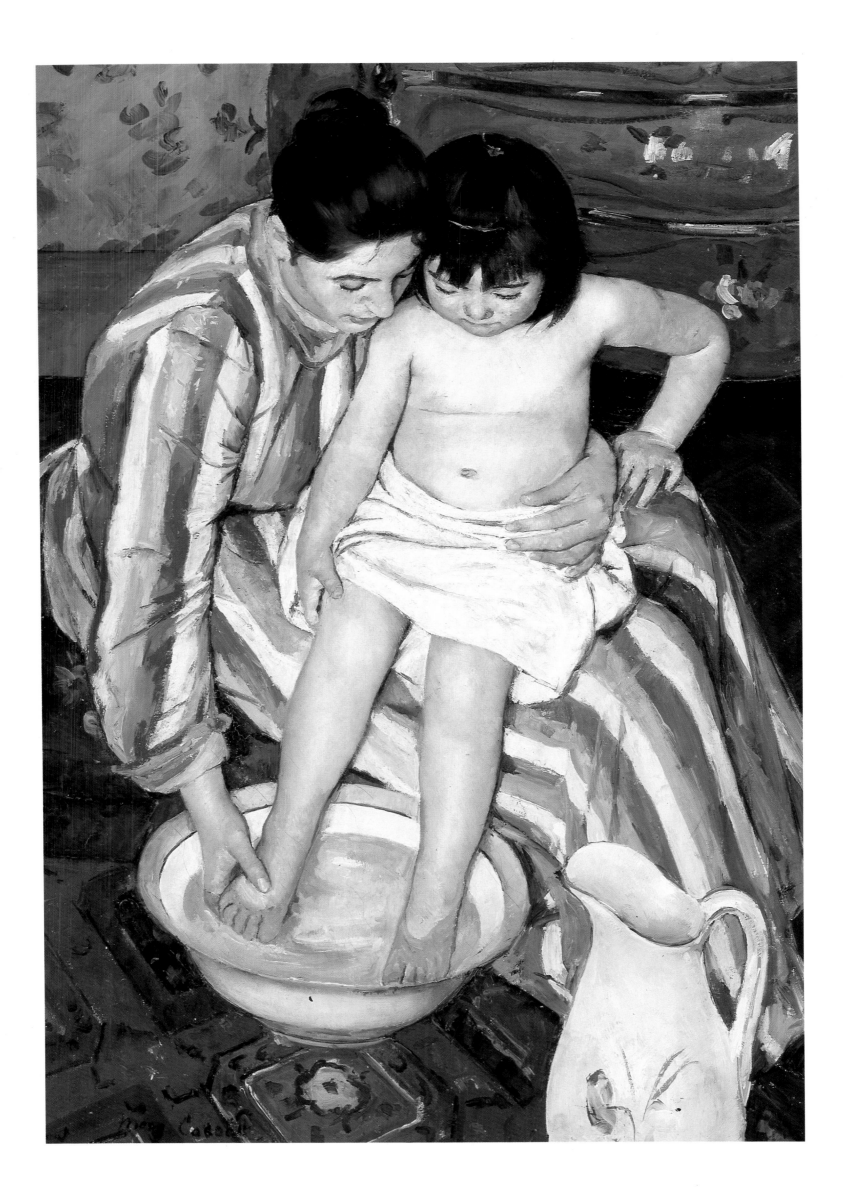

MARY CASSATT

SOPHIA CRAZE

KNICKERBOCKER
PRESS

Page 1:
**Portrait of Mr. Alexander J. Cassatt
and His Son Robert Kelso**, 1884.

Page 2:
The Bath, 1891-2.

Pages 4-5:
Family Group Reading, c. 1905.

Published by Knickerbocker Press
276 Fifth Avenue
New York, New York 10001

Produced by Brompton Books Corp.
15 Sherwood Place
Greenwich, Connecticut 06830

ISBN 1-57715-039-2

Printed in China

Contents

INTRODUCTION 6

THE EARLY PERIOD 21

THE IMPRESSIONIST
PERIOD 27

THE MATURE PERIOD 55

THE LATE PERIOD 95

LIST OF COLOR PLATES 112

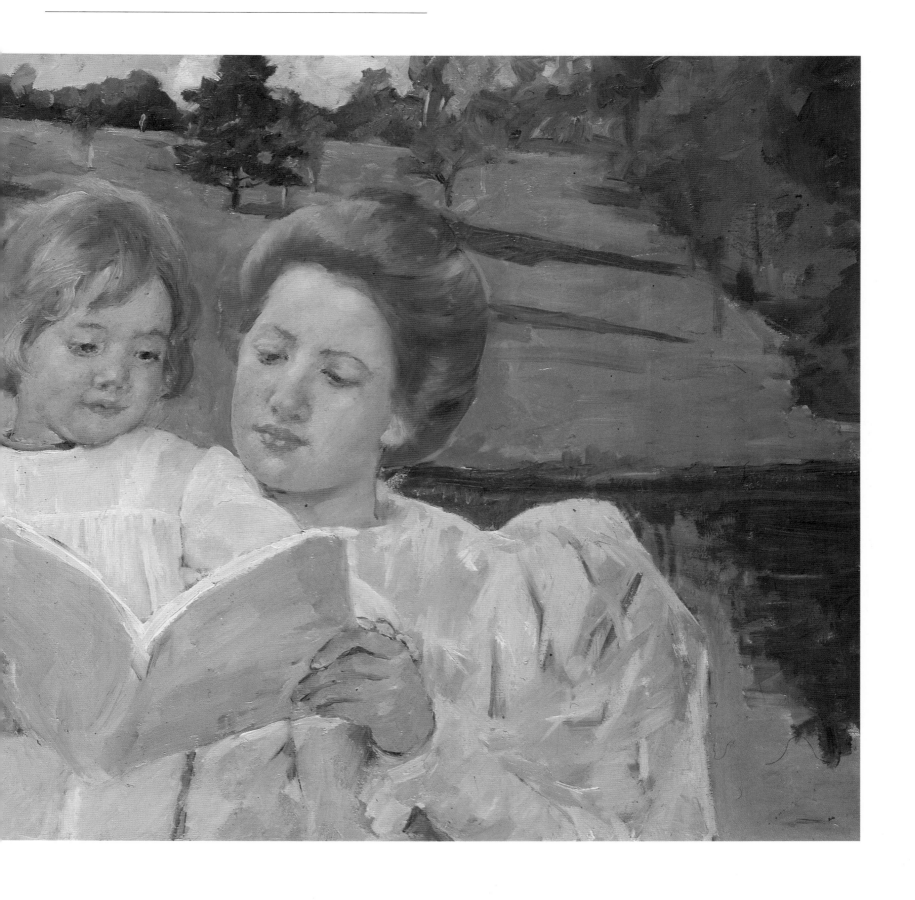

INTRODUCTION

Mary Cassatt was born in an age when most women of her background would have been content to make a good match and enjoy a comfortable existence. But Cassatt's passion for painting was stronger than any conventional desire for marriage, motherhood or social position, and with indomitable spirit and unswerving determination she set out to achieve what was, for a middle-class Victorian woman, the almost impossible dream of becoming a great artist. In fact, she accomplished more in her lifetime than most artists could ever hope for. Not only did she become the foremost woman artist of the

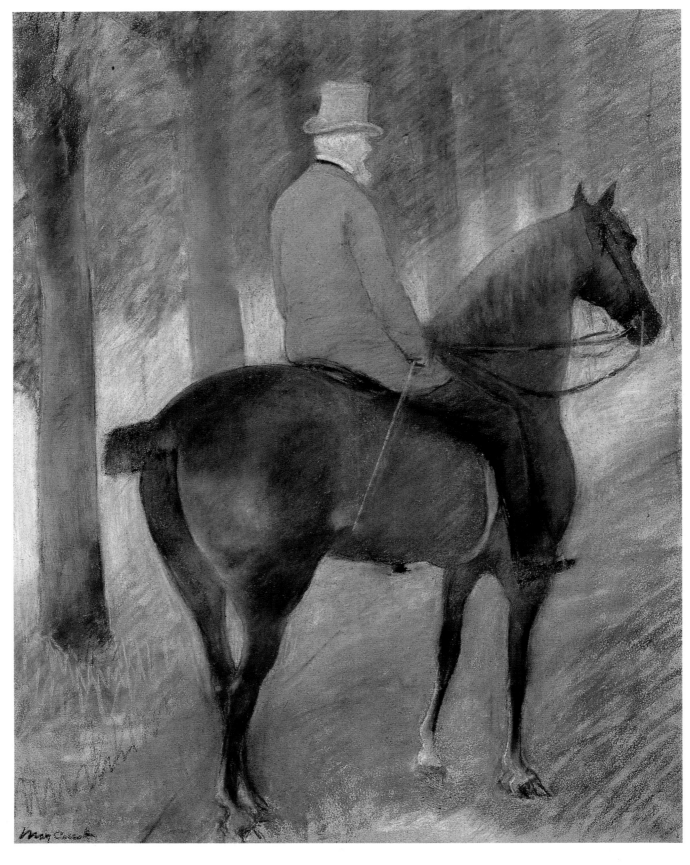

nineteenth century, she was the only American member of the French Impressionist school. Her intimate portraits of women and children are unique in art, and her technical skills and often daring departures from accepted styles were a constant source of astonishment to critics and her fellow painters.

Her strongly held beliefs about art extended well beyond her own work. She labored throughout her life to encourage American collectors to purchase not only the works of her European contemporaries, such as Degas, Pissarro, Monet, Renoir and Manet, but also the works of such earlier masters as Courbet, Goya, El Greco and Rubens. In addition, she never faltered from her lifelong commitment to defend the independence of artists to work unimpeded by the arbitrary standards imposed by juries. A statement she made when declining to accept one of the many awards that she was offered sums up the ideal that she had herself realized in her own life. "In art," she wrote, "what we want is the certainty that one spark of original genius shall not be extinguished."

Mary Stevenson Cassatt was born on 23 May 1844 in Allegheny City, now part of Pittsburgh, Pennsylvania. Her father, Robert Simpson Cassatt, was a wealthy broker who, during her early childhood, served as mayor and president of the Select Council. Although the family name stemmed from a seventeenth-century Huguenot named Cossarts, there was little French blood in the family into which Mary was born. Her mother, Katherine Kelso Johnston, and three of her grandparents, were descendants of Scots and Irish who had settled in America.

Cassatt was introduced to travel, art and European lifestyles at an early age. Almost as soon as her father had settled his family in Philadelphia's fashionable Walnut Street, they all

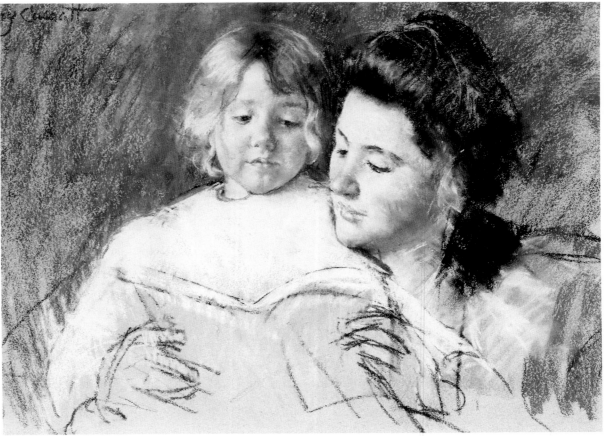

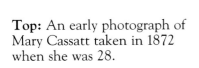

Top: An early photograph of Mary Cassatt taken in 1872 when she was 28.

Right: La Lecture, 1898. A typical Cassatt mother-and-child pastel of her "mature period."

Opposite: Mr. Robert S. Cassatt on Horseback. Mary's father, sketched by her in 1885, six years before his death.

went off to Paris in the fall of 1851, when Mary was only seven, the fourth of five children. The family moved on to Germany in 1852 but returned to Paris again in 1855 to visit the world's fair, where new works of Ingres and Delacroix were viewed with interest by such aspiring artists as Degas, Whistler and Pissarro, who would later become Cassatt's friends and admirers. While there is no record of the young Cassatt's reaction to this exhibit, it may well have had an effect on the 11-year-old girl, for soon thereafter she began to state determinedly that she wanted to be an artist.

Cassatt had also been exposed to another type of artistic experience when she and three of her siblings had their portraits drawn by Baumgaertner while they were still in Germany. This 1854 pencil drawing remains the earliest picture of the artist that has been discovered. At age ten Mary already displayed the physical characteristics that became more pronounced as she grew older. The wide-set but intense grey eyes, shadowed by heavy brows, the sharp and slightly up-turned nose, the

Above: A modeling class at the Pennsylvania Academy of Fine Arts photographed in 1862. Mary Cassatt is on the extreme left.

Right: Portrait of Robert Kelso Cassatt, Mary's nephew. She often used family members as models.

Opposite: Paris in 1879, as it looked at the beginning of Mary's Impressionist period.

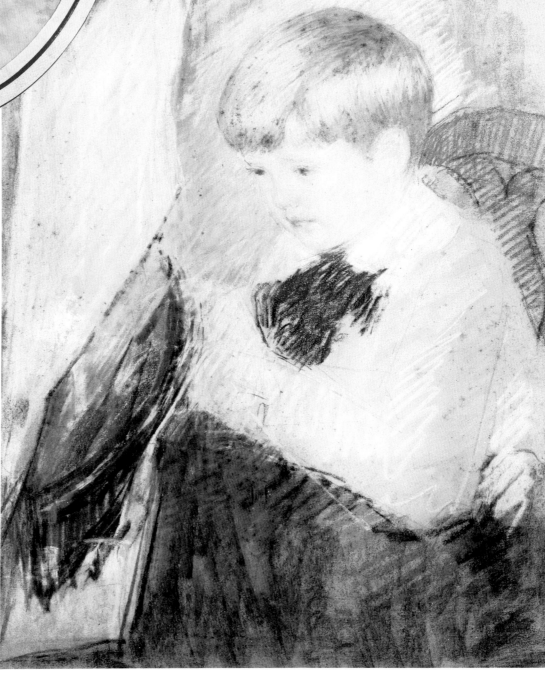

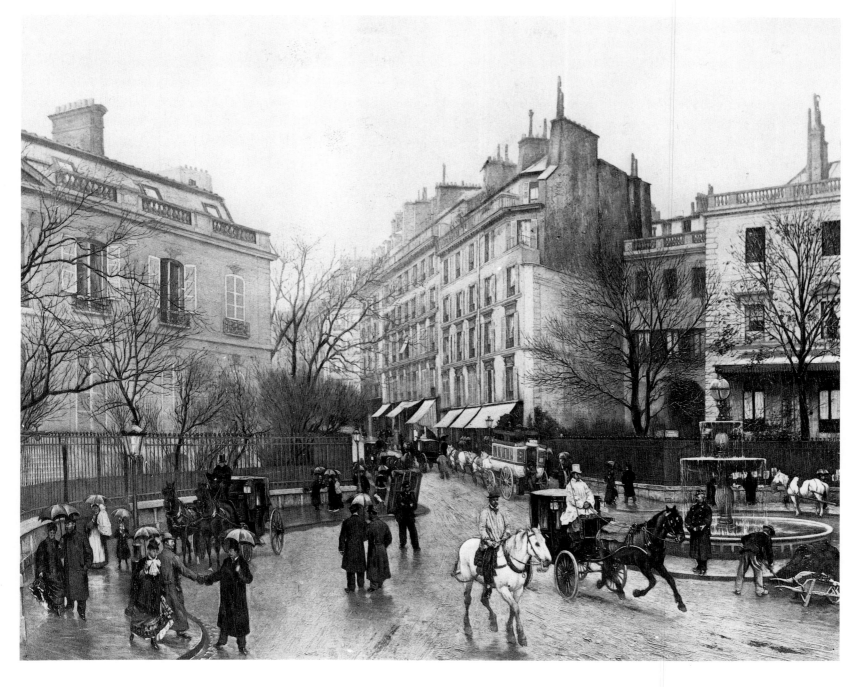

compressed mouth and the prominent chin never made for a beautiful face, but they certainly combined to form one that, over time, increasingly reflected her forceful personality and her overwhelming sense of self-confidence.

The Cassatts finally returned to Philadelphia late in 1855, Mary continued to be tutored in French by her mother and also began to refine her skill as a horsewoman in the Pennsylvania countryside. She would keep a horse and ride for most of her life, until 1888 in fact, when a bad fall put an end to the recreation she favored above all others.

By 1860 Mary was already talking about studying abroad, but in 1861 she enrolled in one of the few art schools in the United States, the Pennsylvania Academy of Fine Arts. Although by this time women took the same classes as men, except for those using nude models, Cassatt found the methods of instruction stultifying and was frustrated by such tedious work as drawing from casts. One exercise that she did believe helped her hone her skills was copying from paintings hanging in the Academy, but this she was only allowed to undertake after two or three years of study. Throughout her life she remained convinced that copying the old masters was the best way to improve tech-

nique, and, in later life, she always advised young artists to pursue this method of self-schooling.

Finally, in 1866, after years of beseeching her father to let her travel abroad to study, she got her way. Her father made sure she went off in the proper style and with all the right introductions, even though he did not believe that it was a fitting career for his daughter or that she was cut out to be an artist. Accompanying Cassatt to Paris was her friend Eliza Haldeman, who had also studied at the Pennsylvania Academy. Another Academy student who went to Europe at about this time was Thomas Eakins. Eakins, however, would pursue a different kind of artistic career than Cassatt, and they never moved in the same circles.

Although women art students were gaining ground in America, in Paris they were still not accepted at the prestigious Ecole des Beaux-Arts. While Cassatt and Haldeman were able to study with some well known teachers of the day, such as Charles Chaplin and Jean-Léon Gérôme, and also had the opportunity to copy the paintings in the Louvre and view the newer works emerging around them, Cassatt was galled by the conservatism of the Paris art world and left the city after a year.

For the next eight years she traveled in Europe, returning to Paris only for short stays. At this time Cassatt was clearly not ready to present her work for exhibition, and she, above all people, recognized the fact. While few of her early works exist, those that do testify to her immaturity as an artist and her need to perfect her skills and find her own individual style.

With Eliza Haldeman she sojourned in artists' colonies in two small French villages. In Ecouen, Cassatt was influenced by two famous genre painters, Edouard Frère and Paul Soyer, who worked mainly on peasant interiors and childhood scenes. But Cassatt also studied with Thomas Couture, who lived nearby in voluntary exile from Paris, where he had achieved fame for his dramatic allegorical paintings. The influence of these teachers can be seen in her painting *A Mandolin Player*, the first of many to be accepted by the Paris Salon (1868) and her first step in achieving the recognition that she so earnestly desired.

But for the outbreak of the Franco-Prussian War and the siege of Paris in 1870, Cassatt would undoubtedly have continued her European studies without interruption. But her parents, who were still skeptical of her ambition and somewhat disapproving of her chosen lifestyle, insisted that she return to America to avoid what they perceived as imminent danger.

Back in America, Cassatt tried to continue painting and even rented a studio in Philadelphia, but when her family moved to the small town of Hollidaysburg the problems of obtaining models and materials forced her temporarily to abandon her work. She wrote frequently to another Philadelphia artist, Emily Sartain, regarding their mutual desire to return to Europe. "I have fully made up my mind that it [is] impossible for me [to paint] unless I choose to set to work and manufacture pictures by the aid of photographs. I have given up my studio and torn up my father's portrait, and have not touched a brush for six weeks, nor ever will again until I see some prospect of getting back to Europe."

Another disappointment in America for Cassatt was the lack of interest in her work. Although she had paintings exhibited with a reputable New York gallery, none sold, and, even though she met with some encouragement in Chicago, a number of her works that had been placed in store windows there were destroyed in the Great Fire of 1871. Cassatt ached for Europe and all that it offered. She wrote to Sartain that she longed for "the pleasure of living in a country where one could have some art advantages" and said that she would "jump at anything in preference to America."

Her chance came later that same year when she received a commission from the bishop of Pittsburgh to make copies of two Correggio paintings in Parma, Italy, for the Cathedral of

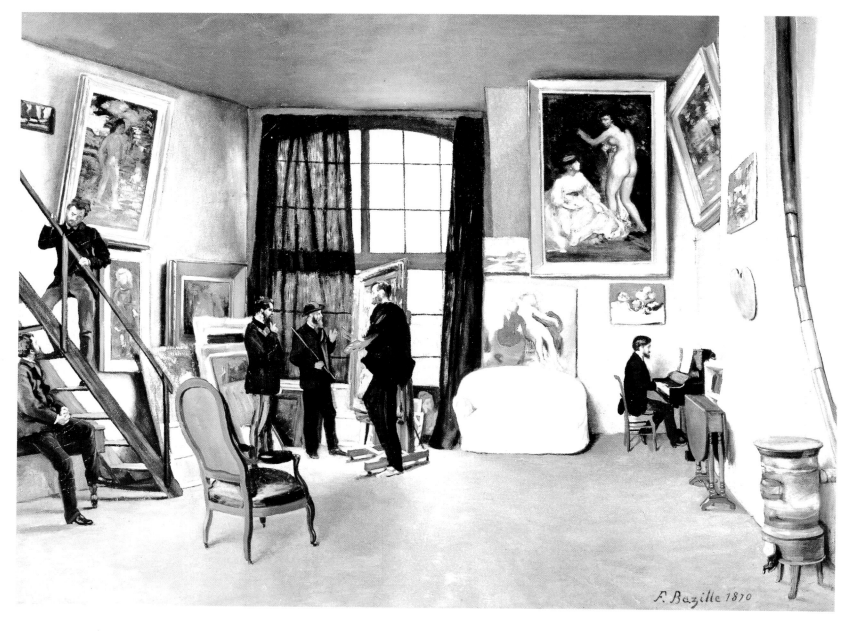

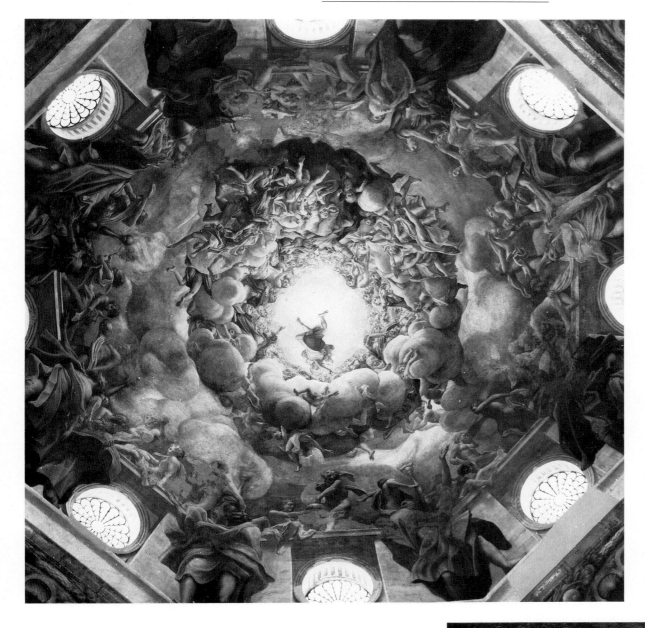

Left: Correggio's amazing mural for the dome of Parma Cathedral was one of Mary's early inspirations.

Below: Cassatt's **Bacchante** of 1872 shows the influence of Correggio in its strong modelling.

Opposite: A typical studio of an Impressionist artist was that of Frédéric Bazille, painted by him in 1870.

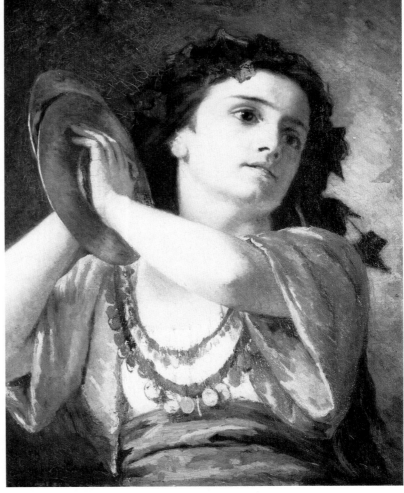

Pittsburgh. Though her parents would pay only for her living expenses, feeling that her artistic endeavors should be self-supporting, this was the opportunity for which she had yearned.

The long voyage took its toll on Cassett, who always suffered from seasickness and claimed that her abhorrence of sea travel was one of the principal reasons she did not return to America for another 20 years. But once in Parma, Cassatt found all the inspiration and encouragement that she had been looking for. She had a studio, the opportunity to copy the old masters and access to models and a teacher, Carlo Raimondi, a respected painter and engraver. Cassatt's enthusiastic response to the works of Correggio and Parmigianino can clearly be seen in two notable works from this period, *Bacchante* and *On the Balcony, During Carnival.*

From Spain, in 1872, Cassatt wrote to Sartain, who had since returned to Paris, about the thrill of working under the influence of the masterpieces that surrounded her. "Velasquez, oh my but you knew how to paint!" she wrote. Although she stated that "I think now that Correggio is perhaps the greatest painter that ever lived," she wrote almost as effusively about the works of other artists, including Murillo and Rubens. Urging Sartain to join her on her travels, she wrote, "Don't mind about clothes or anything, for the people here are little

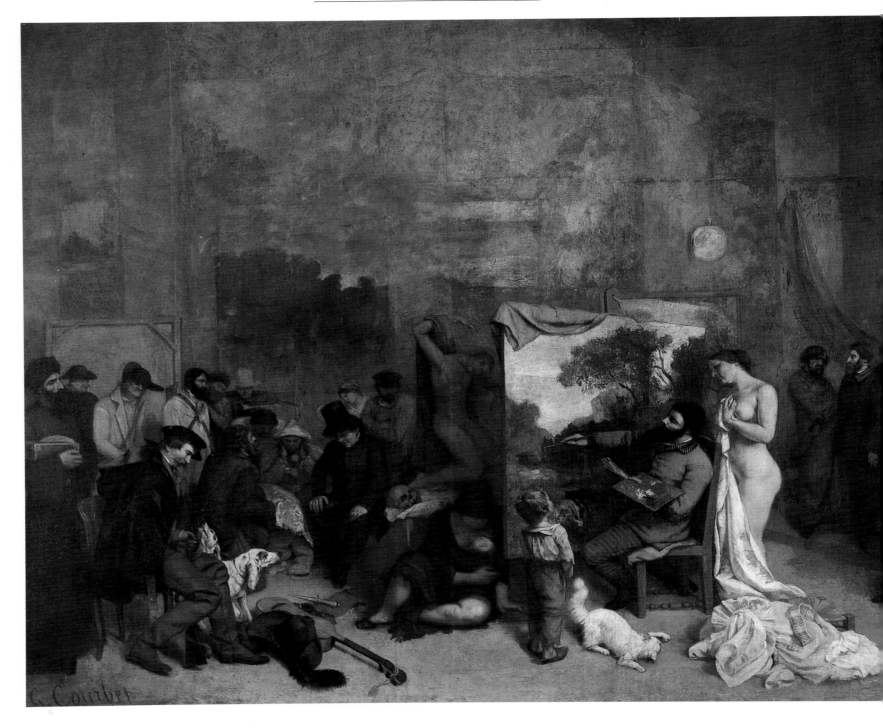

more than barbarians . . . (but) I think that one learns how to paint here. Velasquez' manner is so fine and simple . . . I feel like a miserable little 'critter' before these paintings, yet I feel as if I could paint in this style easier, the manner is so simple."

After a brief return to Paris, Cassatt went to Antwerp to further immerse herself in the works of Rubens and Hals. At the same time, she was becoming increasingly interested in the work of a still-living painter, Gustav Courbet. Her admiration of his insightful realism was reflected in a 1874 work *A Musical Party*, which was also hung in two American exhibitions, at the National Academy of Design in New York and at the Pennsylvania Academy of Fine Arts.

By 1875 Cassatt was approaching an important turning point. She was becoming increasingly dissatisfied both with the rigid standards dictated by the Paris Salon and with the quality of art that hung there. It was at this point that Edgar Degas, who was to become her most trusted friend and artistic advisor, invited her to join the Impressionists. She was already a firm admirer of Degas. Just a year before, Cassatt had persuaded her

friend Louise Elder to purchase one of his paintings. Her acquaintance with Elder, later Mrs. Henry O. Havermeyer, would lead to a lifelong friendship in which Cassatt played a major role in encouraging and influencing Havermeyer to amass what resulted in one of the largest and most important American collections of European art.

When, in 1875, the Salon rejected Cassatt's painting of her sister Lydia and asked her to alter it, Cassatt began a struggle of conscience that lasted two years, a struggle to decide whether to conform to the standards of the Salon or to leap into the precarious world of the rebellious Independents, as the Impressionists preferred to call themselves. After temporizing for a long while, stilling her exuberant brush strokes and her dramatic use of color in order to ensure that the Salon would accept her paintings, she was ready to make the break.

Years later Cassatt told her original biographer, Achille Segard, how important this decision had been for her. "I accepted with joy. I hated conventional art. I began to live." And so did her painting.

Left: Courbet's 1855 **The Studio of the Painter**. Cassatt was much influenced both by Courbet's technique and by his contempt for "official" aesthetic dogma.

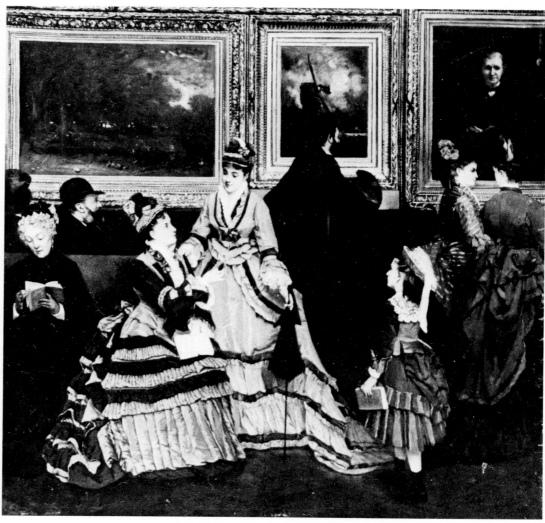

Below: The Salon of 1874 by Jean Béraud. What united the Impressionists most was their opposition to the rigidities of the state-controlled Salon system.

Although individual Impressionists shared only loose stylistic similarities and often had trouble reconciling their varied artistic philosophies, for Degas and Cassatt there was a natural affinity of background, personality and aesthetics. They had been attracted to each other's work before they met, and, once Cassatt embraced Impressionism, they drew together like magnets. Although Degas was ten years older than Cassatt and considerably more experienced as an artist, they did not relate as teacher and student, but as equals, bouncing ideas and opinions back and forth. And Cassatt, who was always known for her forceful personality and strong opinions, could hold her own very well against Degas, who could often be scathing in his criticism.

Their sometimes fiery relationship endured for over 40 years, despite several rifts and Degas' always vitriolic temper, which Cassatt, with her more reasoned and controlled approach, inevitably managed to overcome. While there is no evidence of romance, it is interesting to note that before she died Cassatt burned all his letters to her. Although the intimacies of their relationship remain in question, there is no doubt as to the closeness of their artistic and intellectual association. Degas is quoted as saying that he could never talk to French women as he could to Cassatt, with whom he spent hours discussing the theoretical and practical aspects of art – and, indeed, virtually every other imaginable topic.

As soon as she had broken with the established art world, Cassatt began assimilating many of Degas' techniques into her own work as she prepared for the 1878 Impressionist show. Since that show was eventually cancelled in order not to compete with the Grand Exposition Universelle, by the time Cassatt did exhibit in the fourth Impressionist show in 1879 she had prepared a sizeable body of work. Eleven of her paintings were displayed, along with those of Degas and Camille Pissarro (who dominated the show with over 30 paintings each) and other members of the group, such as Gustave Caillebotte and Claude Monet.

The happiness that Cassatt felt during these early years as an Impressionist, so evident in her exuberant paintings, was en-

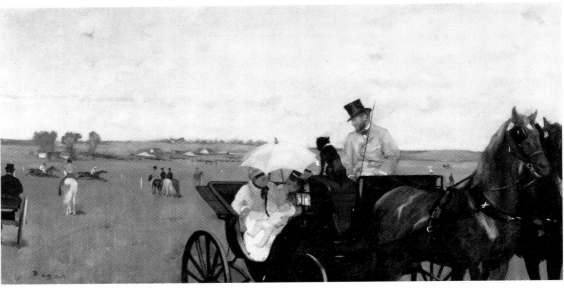

Right: Carriage at the Races, c. 1870, by Edgar Degas.

Below: Mary Cassatt at the Louvre. A Japanese-inspired print by Degas.

Opposite: Monet Painting in his Garden at Argenteuil, 1873, by Renoir, an example of early Impressionist style.

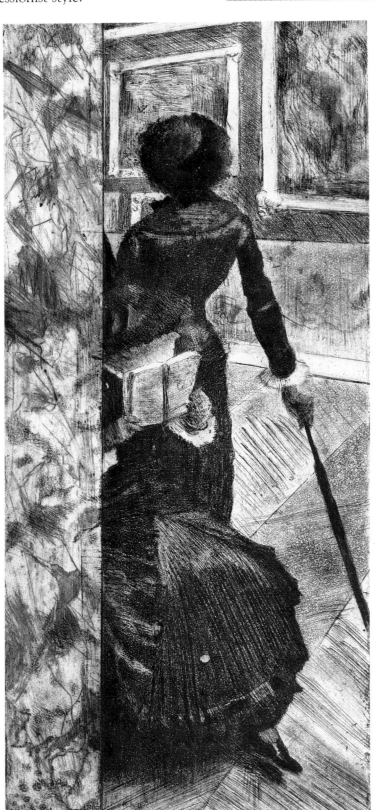

hanced by her strengthening ties with her family, and they became the subject of many of her canvases. The model in *La Loge* and *Lydia Leaning on Her Arms Seated in a Loge* was her sister Lydia, who had moved to Paris with her parents in 1877 in order to be closer to Mary. And it was soon after their arrival that Cassatt painted some of her finest and most sensitive portraits of her mother.

But Cassatt never stood still. As soon as she had mastered one technique or theme she would embark on another. In 1880 she was presented with the perfect opportunity to tackle the potentially cliché-ridden subject of mothers and children when her brother Aleck's family came to visit her, and she was able to observe first hand the intimate relationships between Aleck and his wife, Lois, and her nieces and nephews. *Mother About to Wash Her Sleepy Child*, her first work on the maternal theme, was shown along with some similar subjects at the sixth Impressionist exhibition in 1881.

The art world's reaction to these new works is summed up in excerpts from a review by the celebrated writer J.K. Huysmans, who wrote that Cassatt was ". . . an artist who owes nothing any longer to anyone, an artist wholly impressive and personal." Of her maternal scenes, Huysmans wrote, "Ah! les bébés, mon Dieu! how often have their portraits exasperated me! A whole series of French and English dabblers have painted them in such stupid and pretentious poses . . . For the first time I have, thanks to Mlle. Cassatt, seen pictures of children who are ravishing – tranquil and bourgeois scenes painted with a kind of delicate tenderness – completely charming."

The year before, Cassatt had shown only a few pieces at the fifth Impressionist exhibition because she and Degas were busy trying to launch a periodical, *Le Jour et La Nuit*. Although this project never got off the ground, it provided an opportunity for Degas and Cassatt to work intensely together for over a year, and this experience drew them even more closely together as friends who shared a common vision. Their ties were further strengthened when they both withdrew from the seventh Impressionist exhibition in 1882 – Degas because Caillebotte and a strong core of the group did not want to include Degas' non-Impressionist friends in the show. Joseph Durand-Ruel, the

dealer who mounted the Impressionist exhibitions, still held the exhibit that year, despite the internal disagreements, but the schism in the group, coupled with an economic recession that crippled the art market, caused such problems that the Impressionists would not show again as a group for another four years.

Degas and Cassatt continued to work closely together. He often used her as a model, and he continued to criticize her work, paying her backhanded compliments such as, "I will not admit that a woman can draw so well."

Although by this time Cassatt was firmly established in France, she was still barely known in her own country. Several of her paintings were exhibited in large exhibitions in New York and Philadelphia, but never enough to make an impact, except on a few discerning reviewers.

The years between 1882 and 1886 were personally stressful for Cassatt. Her sister Lydia died of Bright's disease, and both her parents were aging and their health deteriorating. Most of Cassatt's letters from this time reflect her concern with family matters, whereas in earlier more carefree years they had been full of exuberant discussions about art. Despite the fact that so much of her time was now taken up with caring for her parents, which often involved taking them to warmer climates in the winter, Cassatt did not falter in her dedication to painting and continued to work daily in her studio.

At the same time, she was busy encouraging both her brother Aleck and her friend Louise Havermeyer to purchase the works of contemporaries whom she admired, especially Degas, Pissarro and Monet. The collections that were amassed as the result of Cassatt's efforts were the first of a wave of Impressionist collecting that would sweep America and eventually fill its museums.

The final Impressionist show in 1886 was organized and financed by Cassatt, Degas and Morisot, and among the six oils and one pastel that Cassatt exhibited was a work called *Girl Arranging Her Hair*, which Cassatt had painted to prove a point to Degas about style. For this painting Cassatt went out of her way to find an ugly model in order to stress that the subject of the painting was less important than its execution. Apparently she made her point, for Degas enthused to Cassatt about the work, "What drawing, what style!"

The same year that Cassatt exhibited as an Impressionist for

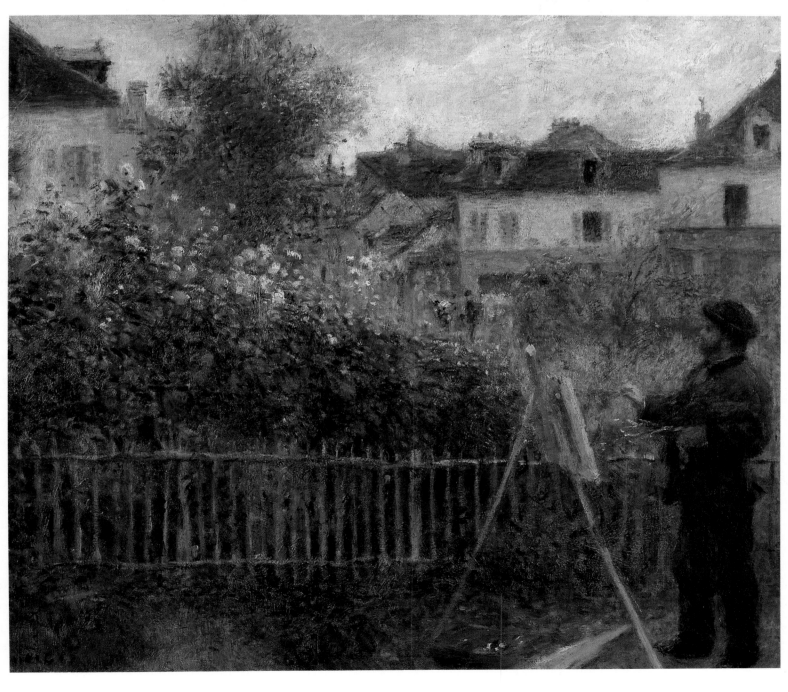

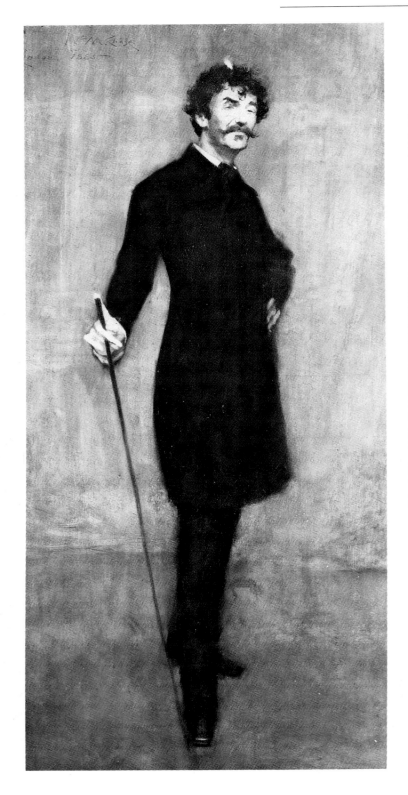

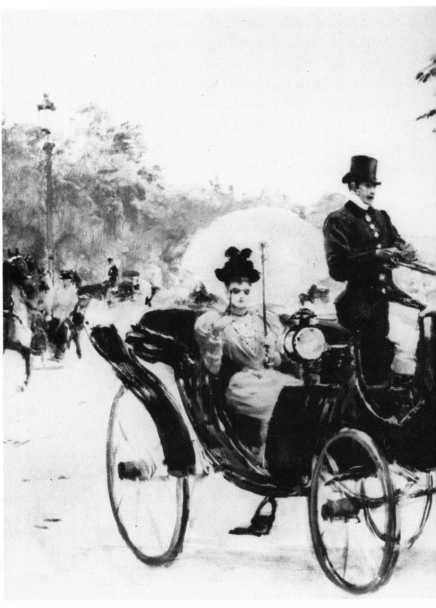

the last time in France marked the first exhibition of French Impressionists in America. It was a huge exhibit, organized by Durand-Ruel in New York, but only two of Cassatt's paintings were included. At that time her American contemporaries, Whistler and Sargent, were both better known in their home country than Cassatt. Although Cassatt thought highly of Whistler, she refused to speak to Sargent after he declined her invitation to join the Impressionists. The gifted Sargent certainly did not lack the technical facility to paint impressionistically, but in 1885 he had fallen out of favor in Paris after the scandal caused by his famous *Madame X*, and Cassatt was contemptuous of Sargent's subsequent decision to adjust his work to meet the conventions of the time and to abandon pursuit of stylistic innovation.

For Cassatt, who had always insisted on nurturing her individual style, the gradual waning of the Impressionist move-

ment was no great tragedy, for it provided her an opportunity to stretch her talents in exciting new directions. Parisian artists who had been admiring the colorful Japanese woodcuts for many years were provided with an exceptional opportunity to see large collections of these ukiyo-e when the Ecole des Beaux-Arts mounted an exhibition of them in 1890. The following year Cassatt, inspired by the Japanese work, produced a series of ten exceptional aquatint color prints that, along with her drypoint prints, brought her critical acclaim in yet another area – as a printer and engraver.

In 1891, even though Cassatt and Pissarro had shown with the *Société des peintres graveurs francais* during the two previous years, they were both excluded from the exhibit because the group now decided to limit membership to French citizens. As a result, Cassatt showed her remarkable prints, along with four mother and child paintings, at her first one-person exhibition,

Paris in the Gay 90s, as seen by Jean Béraut in **Carriage on the Champs Elysées**.

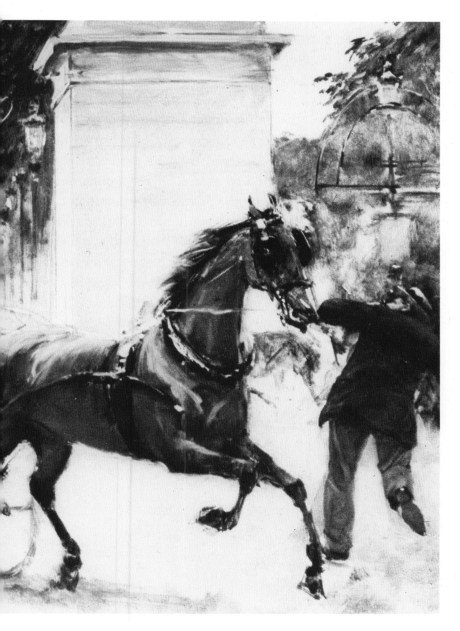

held at the Durand-Ruel gallery. It was a great success and considerably advanced her reputation in Europe. But the recognition that Cassatt longed for from her fellow Americans was still not forthcoming. As she wrote Durand-Ruel, "I am still very much disappointed that my compatriots have so little liking for any of my work."

The following year, however, Cassatt was given another opportunity to make an impact on the American public when she was commissioned to paint a massive mural for the World's Columbian Exposition in Chicago in 1893. Cassatt embarked on this new endeavor with typical dedication and worked on it for more than a year. She had been given the theme of "Modern Woman" for her mural, which, counterpoised with another by Mary Fairchild MacMonnies on "Primitive Woman," were to adorn the Woman's Building at the great fair. Cassatt did not have an easy time with the mural, and her

struggles, as well as her volatile relationship with Degas, are illustrated in a letter she wrote to a friend during the process. "I have been shut up here so long now with one idea, that I am no longer capable of judging what I have done. I have been half a dozen times to the point of asking Degas to come and see my work, but if he happens to be in the mood he would demolish me so completely that I could never pick up myself in time to finish for the exposition."

Despite the great lengths to which Cassatt went in order to execute a work of art that she described "as bright, as gay, as amusing as possible," reserving "all the seriousness for the execution, the drawing and painting," it was not well received and was destroyed when the exposition was dismantled.

The themes that she depicted in her mural are echoed in much of her other work of the same period. The subject that she chose for the mural's center panel, for example, "Young Women Plucking the Fruits of Knowledge and Science," was incorporated into such works as *Young Women Picking Fruit* and *Baby Reaching for an Apple*. Although it would be several years before Cassatt openly allied herself with the feminist suffrage movement, the choice of such themes fairly explicitly illustrated her belief, as exemplified in her own life, that women could have the same opportunities as men if they would only reach out and grasp them.

While Cassatt suffered personal losses during this period – her father died in 1891 and her mother in 1895 – their deaths also freed her from the burden of responsibility that she had been carrying for many years. And her life was enriched by another branch of her family when her brother, Joseph Gardner Cassatt, his wife and children spent two years in Paris (1895-1897). They all became the subjects of some exquisite portraits.

By 1884 Cassatt had acquired enough money to purchase a chateau, Mesnil-Beaufresne, where she would retreat from her Paris apartment, and she often entertained visiting artist and intellectuals in one or the other of her homes. One of these visitors, the English writer Vernon Lee, described Cassatt as "nice, simple, an odd mixture of self-recognizing artist, with passionate appreciation in literature, and the most childish, garrulous American provincial." Cassatt, who was also sometimes described as outspoken, opinionated and domineering, one who put people off with her air of a "grande dame," might well have agreed with Lee's description, for she was always assertively proud of her American heritage.

In 1895 Cassatt at last had a one-person show in America, at the Durand-Ruel galleries in New York. Most of the work in this exhibition had been shown in a large retrospective that Durand-Ruel had held in Paris in 1893, which included 98 works: 17 paintings, 14 pastels and 60 prints. The Paris show had been a heartfelt tribute to the woman who had made such an impact on the French art world, but the New York show failed to secure anything like a similar level of respect for the expatriate artist who so proudly claimed, "I am American, simply and frankly American."

When she returned to America in 1898, after an absence of 20 years, the *Philadelphia Ledger* ran a notice only a few lines in length that referred to Cassatt merely as having been "studying painting in France." Undismayed by so meagre a welcome, Cassatt immediately set to work painting a new series of portraits, including *Mother Combing her Child's Hair* and *Young Mother Sewing*. And to all who would listen she continually extolled "our little band of Independents."

The *Ledger's* unawareness of Cassatt's importance was not altogether typical. In fact, her reputation in the US had been growing steadily, and as a result of this trip it suddenly peaked. Cassatt was at last acknowledged in her own country as one of its great living artists, on a par with Whistler, Sargent, Homer and Eakins. Now, in a rush, came requests for her to serve on juries and to accept several prestigious awards – all of which she refused. Instead she used the opportunity to express, once again, her unremitting abhorrence of the jury system in her responses to notices that informed her she had won, for her painting *The Caress*, the Lippincott Prize of the Pennsylvania Academy of Fine Arts and the Norman Wait Harris Prize of the Art Institute of Chicago. In France she would soon be awarded the highest honor the country could bestow on a non-citizen when she would be named a Chevalier of the Legion of Honor.

In 1903 Cassatt wrote to the Havermeyers, who had since returned to America, that there was to be an exhibition "of all our set, including Manet, Degas, Monet, Sisley, Berthe Morisot and myself." Whether they could, in fact, still be considered a "set" is arguable, but she retained close ties with all her contemporaries for the rest of her life, and their relationships were seldom affected by the different artistic directions they chose to follow.

Nevertheless, they were all now under a certain degree of pressure from their post-Impressionist challengers. Although Cassatt insisted that the newer artists of the Picasso, Matisse, Gertrude and Leo Stein circle missed the point of the Impressionist rebellion, this group inevitably had some influence on her and her contemporaries. Degas and Cassatt intensified their color and boldness of stroke in their pastels, Renoir created what Cassatt referred to as his "fat red women" and Monet increasingly retreated into a private world dominated by his obsession with the garden at Giverny, the results of which Cassatt dismissed as "glorified wallpaper." And as the prices for Impressionist art increased, the artists in her circle began to drift away from the Paris art scene. Cassatt, Renoir and Monet lived in the country, and Degas more-or-less alone wandered the streets of Paris.

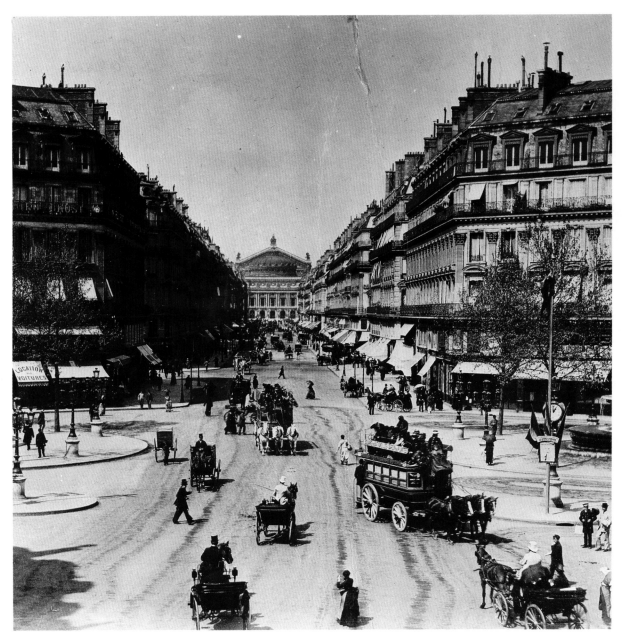

Right: Avenue de l'Opera at the turn of the century. By then many Impressionists had abandoned Paris.

Opposite: A characteristic Cassatt drypoint: **Jeannette Wearing a Bonnet**, 1904.

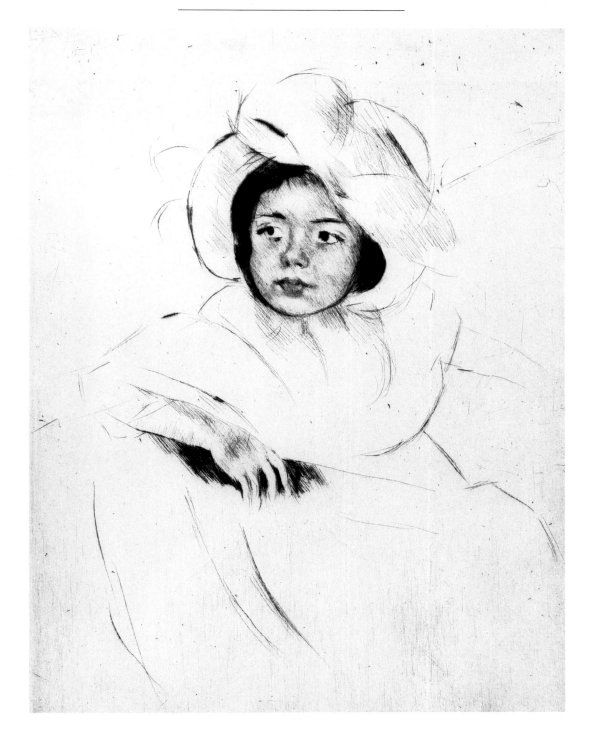

The advent of World War I disrupted what was left of the old Impressionist circle even more. The Western Front cut diagonally across northern France and came within 50 miles of Cassatt's home. She fled to southern France, where she rented a villa. Although she returned to Beaufresne and Paris several times during the war, her work was seriously interrupted, but at least before that, during the first decade of the century, Cassatt had produced many more notable works, including *After the Bath* and *Mother and Child*.

Although her whole life had been that of an independent woman, until 1910 she had not associated her strongly feminist views with the movement at large. But the strong, conservative leadership of Carrie Chapman Catt attracted such individuals as Cassatt and Havermeyer into the heart of the movement, and by 1915 Cassatt helped organize the "Suffrage Loan Exhibition of Old Masters and Works by Edward Degas and Mary Cassatt" at New York's Knoedler gallery.

As she grew older, and no longer had to work for recognition or care for her family, she had more time to explore her many interests. She also began to settle her affairs and make sure that her work was placed in the museums and collections where they would be appreciated. She divided her time between her chateau, her Paris apartment and the south of France in the winter, sometimes taking off again for long periods to Italy, Spain, America (where she went for the last time in 1908) or Egypt. She also kept up an active social life, entertaining family members and people from the art world. But by 1915 a series of operations had not improved the cataracts that had developed in her eyes, and, although she was never completely blind, she at last had to abandon painting. She remained alert both physically and mentally into her eighties until, weakened by diabetes, she died on 14 June 1926.

As the news of her death spread throughout the world, critics and fellow artists in Europe were lavish in their eulogies. But perhaps nothing would have pleased her more than the obituary in her own hometown paper, the *Philadelphia Inquirer*, that said unequivocally that she was "considered by the critics of two continents one of the best women painters of all time."

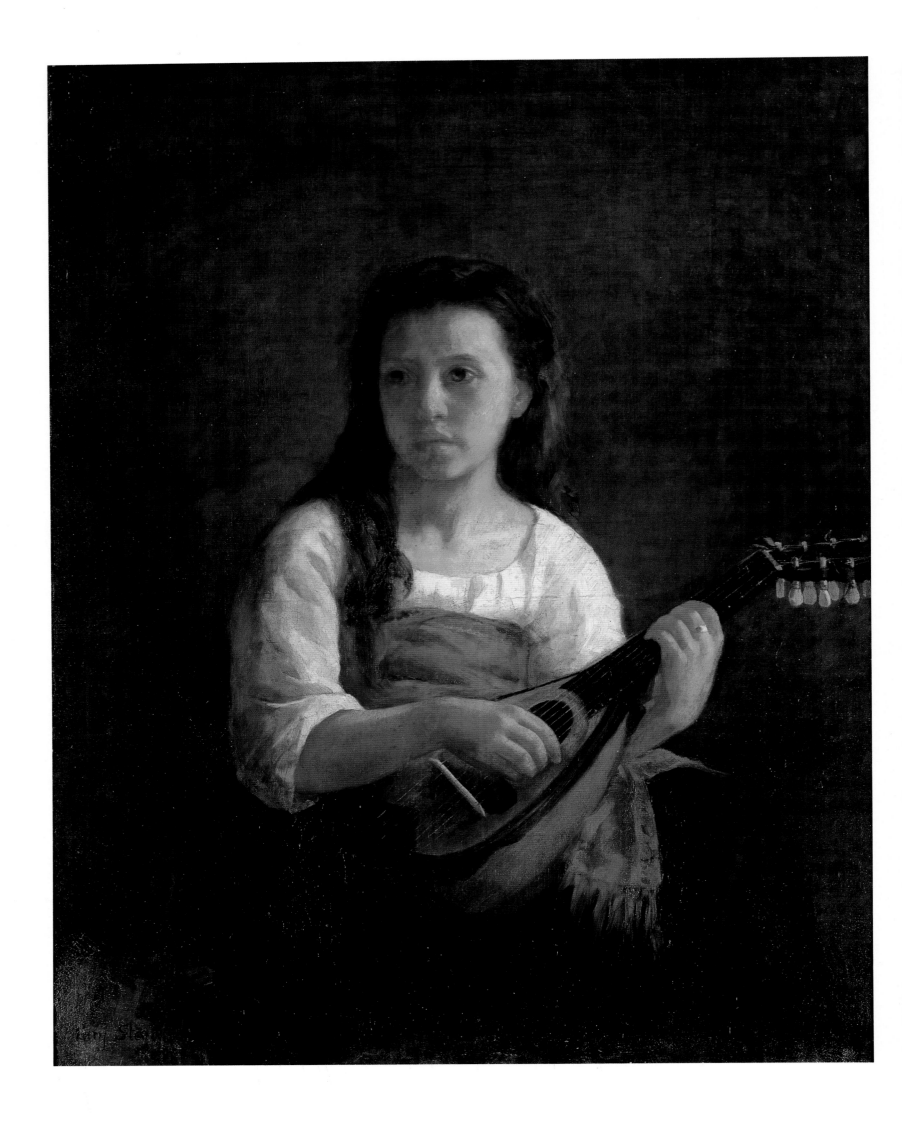

THE EARLY PERIOD

Mary Cassatt was a serious art student for eight years before she began to produce work worthy of recognition. Of the few paintings that remain from her earliest years in America and Europe, most display the need, which she recognized only too well, to develop her basic skills. She was convinced that the best way to do this was to study the great masters of the past, and the influences of those she most admired can be clearly seen. But Cassatt also took advantage of the opportunity to study with a series of well-regarded contemporary teachers, and it was her openness to a wealth of artistic influences that would eventually lead her to develop her own unique style.

Her perseverance began to bear fruit in 1868 when she produced *A Mandolin Player*. Strongly influenced by the contemporary French genre painters, this was the first of her works to be accepted by the prestigious Paris Salon. After a second work, now lost, was included in the 1870 Paris Salon exhibition, Cassatt knew that she was on her way to achieving mastery of her art and the accompanying recognition that she had so diligently pursued since she was 16.

As a student in Italy, Cassatt was next exposed to the works of Correggio and Parmigianino. *Bacchante*, painted in 1872, reflects the influence of Correggio's unpretentious and unsentimental virgins and children, and the statuesque figures strongly resemble those of Parmigianino. Another work, executed in the next year, *On the Balcony During Carnival*, epitomizes Cassatt's work in Parma and the way she had begun to combine traditional techniques with contemporary themes. The fact that balcony scenes were in vogue at the time in the Paris Salon may have contributed to the important position given this painting when it was exhibited there and, as the painters sometimes put it, "hung on the line."

The influence of Rubens' warm flesh tones and brilliant use of colors began to emerge in Cassatt's paintings after 1873, and *The Young Bride (La Jeune Mariée)* shows this well. Another artist whom Cassatt greatly admired was Courbet, and in some of her works of this period it is possible to detect Courbet's sense of realism and his use of thickly painted dark colors and white highlights.

Despite her affection for the old masters and for realism in general, Cassatt's evolving personal style was beginning to impel her in the direction of the Impressionists. The first acknowledgement of this came when Edgar Degas saw her *Portrait of Madame Courtier* at the 1874 Paris Salon exhibition and remarked to a friend, Joseph Tourney, "It is true. There is someone who feels as I do."

As she continued to progress Cassatt cared less and less about conforming to the dictates of the Paris Salon. After her 1875 oil *The Young Bride* and several others were rejected by the Salon, Cassatt made some halfhearted attempts to compromise, but in 1877 she finally broke with the official art world and took the bold step of becoming the first and only American to join the ranks of the rebellious Impressionist group.

The Mandolin Player
c. 1872, oil on canvas, 29×36 in.
Private Collection

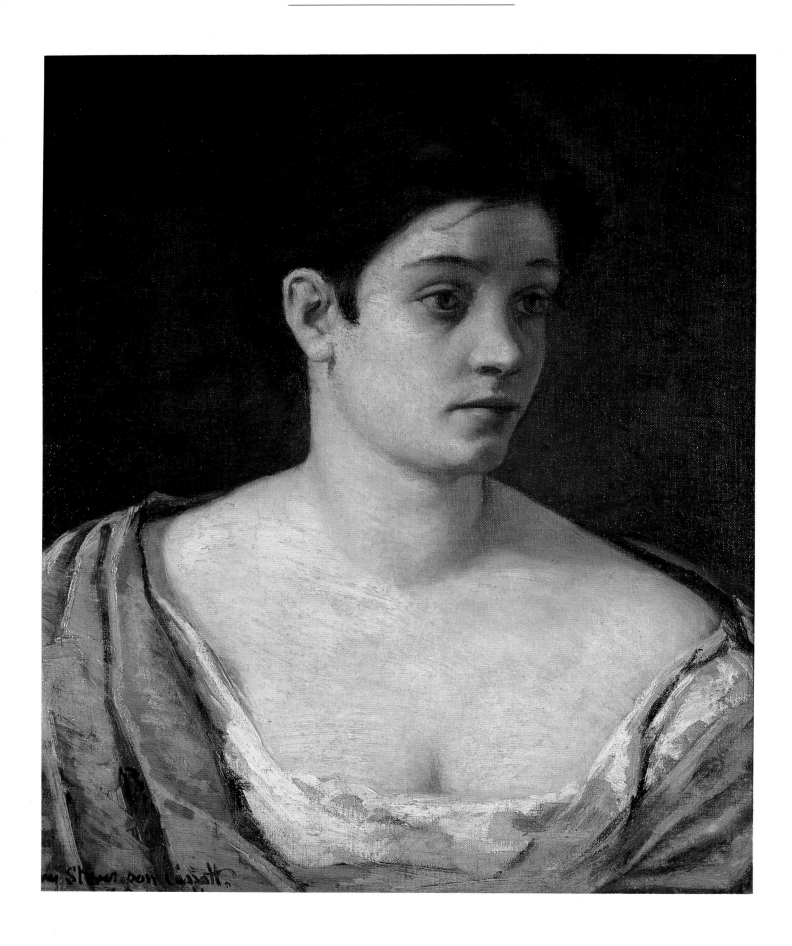

Portrait of a Woman
1872, oil on canvas, 23×19¾ in.
Inscribed and signed LL: Cassatt
Gift of Mr. Robert Badenhop,
1955 The Dayton Art Institute, OH
(55.67)

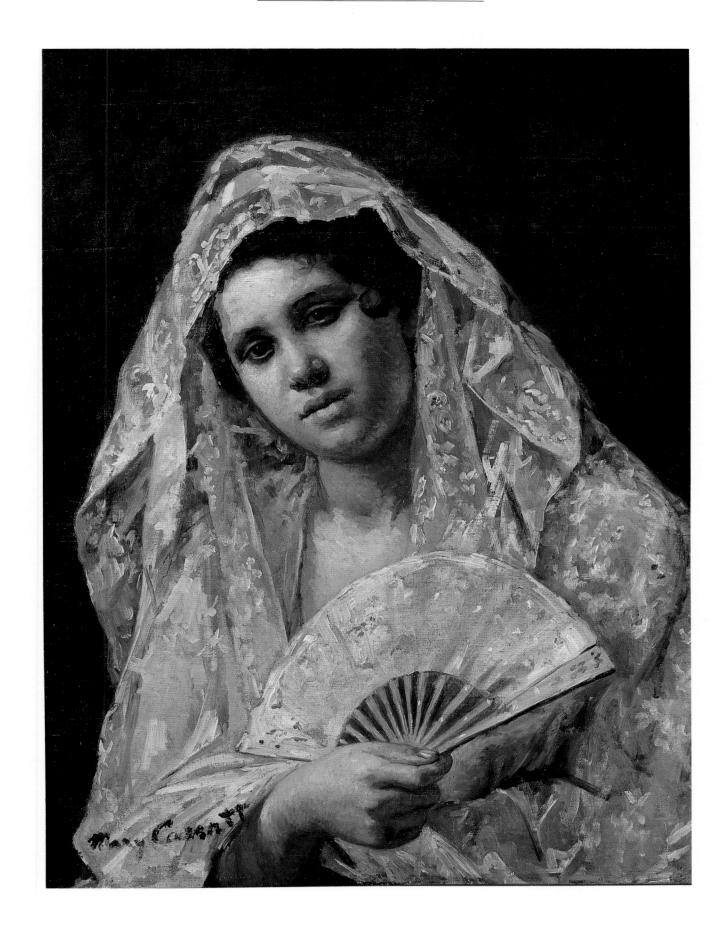

Spanish Dancer Wearing a Lace Mantilla
1873, oil on canvas, 26¾×19¾ in.
Gift of Victoria Dreyfus,
National Museum of American Art,
Smithsonian Institution, Washington, DC
(1967.40)

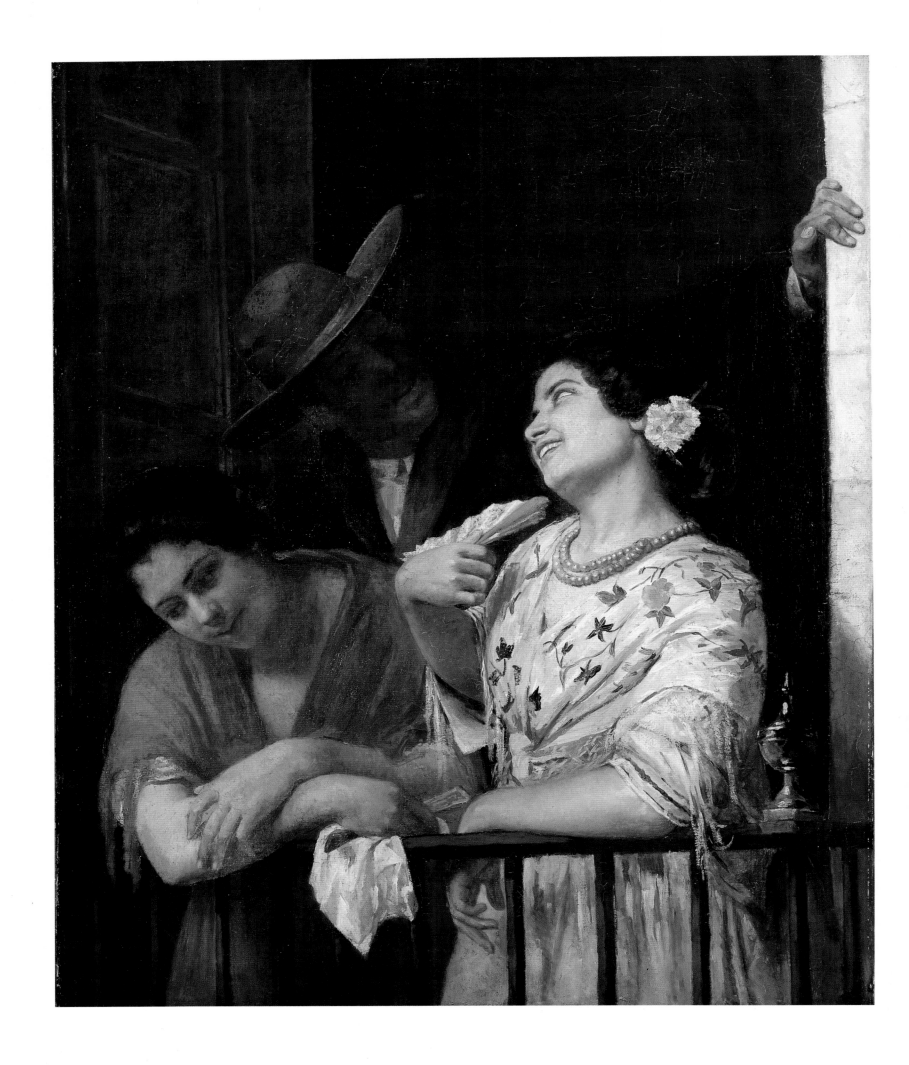

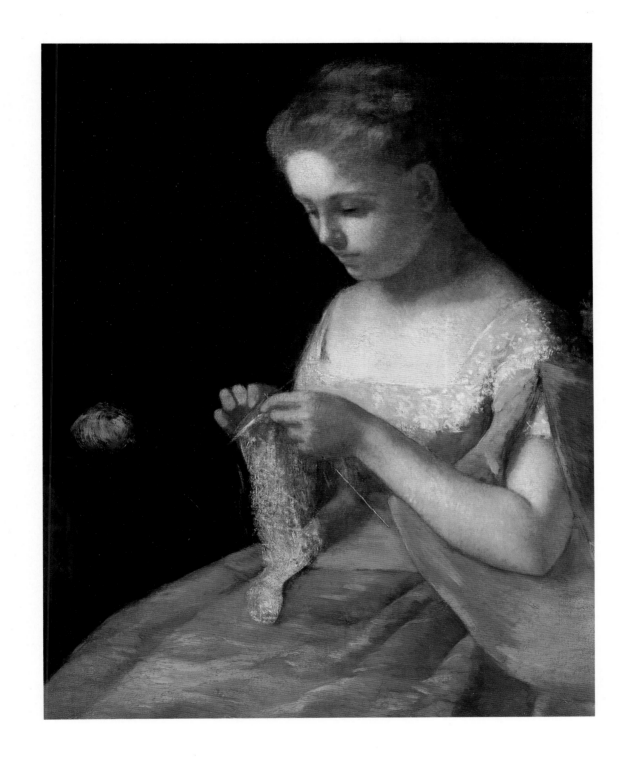

Left:
On Balcony, During Carnival
1873, oil on canvas, 39¾×32½ in.
W. P. Wilstach Collection,
Philadelphia Museum of Art, PA
(W'06-1-7)

La Jeune Mariée (The Young Bride)
c. 1875, oil on canvas, 34½×27½ in.
Gift of the Max Kade Foundation,
Collection of The Montclair Art Museum,
NJ
(58.1)

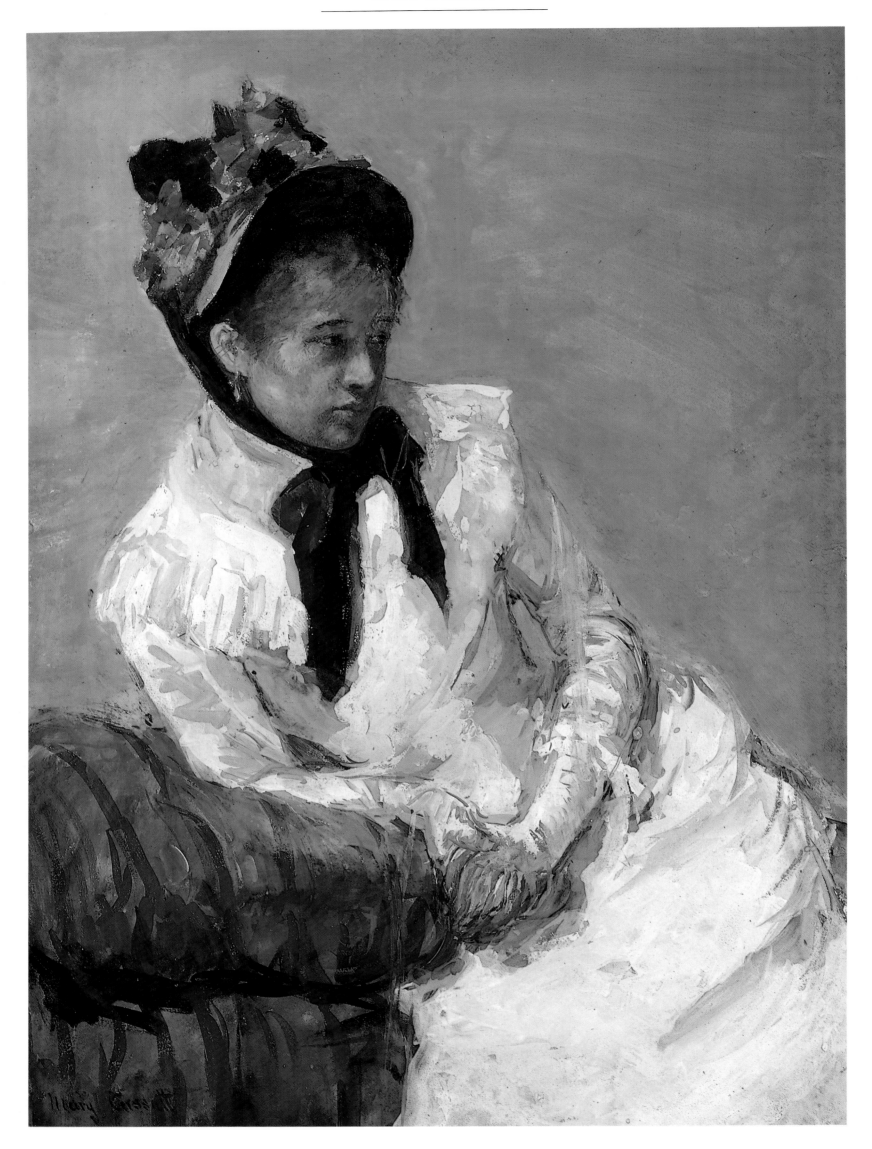

THE IMPRESSIONIST PERIOD

Mary Cassatt was the only American ever invited to join the renegade French group who called themselves the Independents, or more formally, *La Société anonyme des artistes, peintres, sculpteurs, graveurs, etc.* The term "Impressionist" was coined derisively by a reviewer writing of one of Monet's canvases, *Impression: Sunrise*, but it soon lost its negative meaning and became the name by which the group was most commonly known. Yet, it was less a shared aesthetic vision that united them than a desire for independence from official artistic standards and the arbitrary judgments of the jury system.

Cassatt, who was invited to join the group by Degas, shared his particular vision most closely, and her canvases from the late 1870s and early 1880s strongly reflect his influence. Her 1878 *Portrait of the Artist*, with its use of light and a dramatic diagonal thrust, shows a marked difference in form from her previous work and marks the beginning of her homage to Degas. It is obvious from a letter that Cassatt wrote several years later how close she and Degas had already become by 1878. He had been helping her with a painting that she did that year, *Little Girl in the Blue Armchair*, one of the most remarkable of her early Impressionist career. "It was the portrait of a child of a friend of Mr. Degas. I had done the child in the armchair and he found it good and advised me on the background and he even worked on it," she wrote.

Although her most memorable early paintings were oils, Cassatt had experimented with several other media, including pastels. The influence of Degas and Manet in her use of pure color in pastels is clearly seen in many of her turn-of-the-decade works, including those for which she used her sister Lydia as a model – *La Loge*, for example, and *Lydia Leaning on Her Arms Seated in a Loge*. Her subject matter changed along with her methods of execution. Whereas she would have formerly made sketches from models posed in her studio, now she took a sketch pad to record people in public places. Several Impressionists, and notably Degas, were fond of theater and opera scenes, and Cassatt tried her hand at such subjects as well. But, never content to be an imitator, she always focused her attention on the audience rather than on the performers.

Nowhere was Cassatt's ability to balance the contradictory demands of Impressionism and conventional realism more visible than in her paintings of her family. While maintaining the balance between fragmentation and compositional unity, high color and natural tone, public and private, beauty and ugliness, Cassatt also had to walk the fine line between spontaneity and genre. S.N. Carter, a reviewer in New York, who had seen a portrait of Cassatt's mother, *Reading Le Figaro*, in an exhibition held by the Society of American Artists, testifies to Cassatt's success in mastering these balances: "Among the technically best pictures in the entire collection was Miss Cassatt's portrait . . . It is pleasant to see how well an ordinary person dressed in an ordinary way can be made to look; and we think nobody seeing this lady reading this newspaper through her shell "nippers" and seated so composedly in her white morning-dress, could have failed to like this well-drawn, well-lighted, well-atomized, and well-composed painting."

It was in 1880 that Cassatt produced her first works on the theme for which she would become most famous – mother and child. Cassatt received immediate acclaim for her skill in portraying the intimate scenes in such works as *Mother About to Wash Her Sleepy Child* with a straightforwardness that made the paintings all the more real. Cassatt had reached the peak of her career as an Impressionist when two of her mother-and-child works, along with two paintings of her sister Lydia, *Five O'Clock Tea/A Cup of Tea* and *Lydia Reading in the Garden*, and one of her mother reading to her nieces and nephews, were exhibited at the sixth Impressionist exhibition held in Paris in 1881.

A rift within the Impressionist group resulted in Cassatt and Degas withdrawing from the exhibition the following year, and for the three subsequent years there were no Impressionist shows. Although Cassatt retained ties with the group until she participated in their final show in 1886, during the interim her own style began to change, reflecting new influences and an increasing emphasis on line rather than mass. One of the most striking paintings from this period, which Degas called, "distinction itself," is *Lady at the Tea Table*. This portrait of her cousin, Mrs. R.M. Riddle, is far more severe than her earlier Impressionist work and illustrates the use of more controlled brushwork, as well as the influence of Japanese art, in which Cassatt had now begun to take an interest.

In the Loge,
c. 1879, Pastel and metallic paint on
canvas, 26¾×32½ in.
Gift of Margaret Sargent McKean,
Philadelphia Museum of Art, PA
(1978-1-7)

Page 26:
Portrait of the Artist
c. 1878, gouache on paper, 23½×17½ in.
Bequest of Edith H. Proskauer,
The Metropolitan Museum of Art, New
York, NY
(1975.319.1)

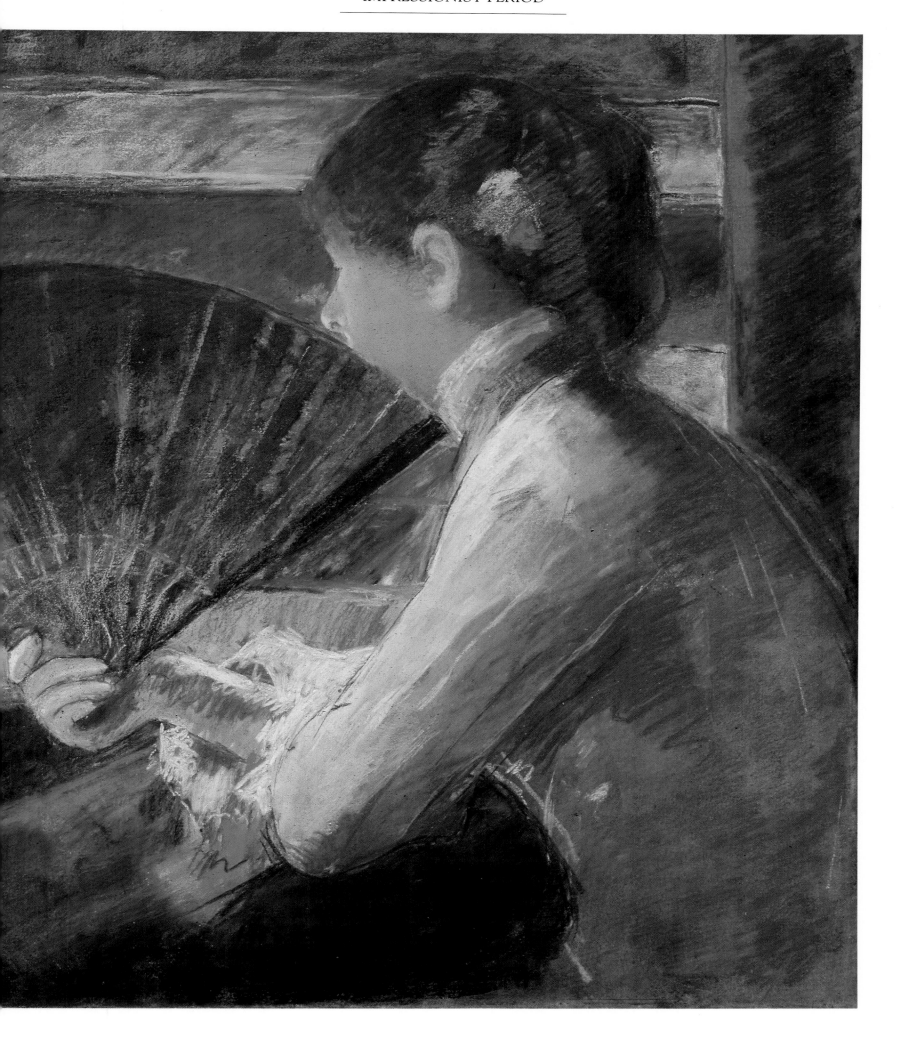

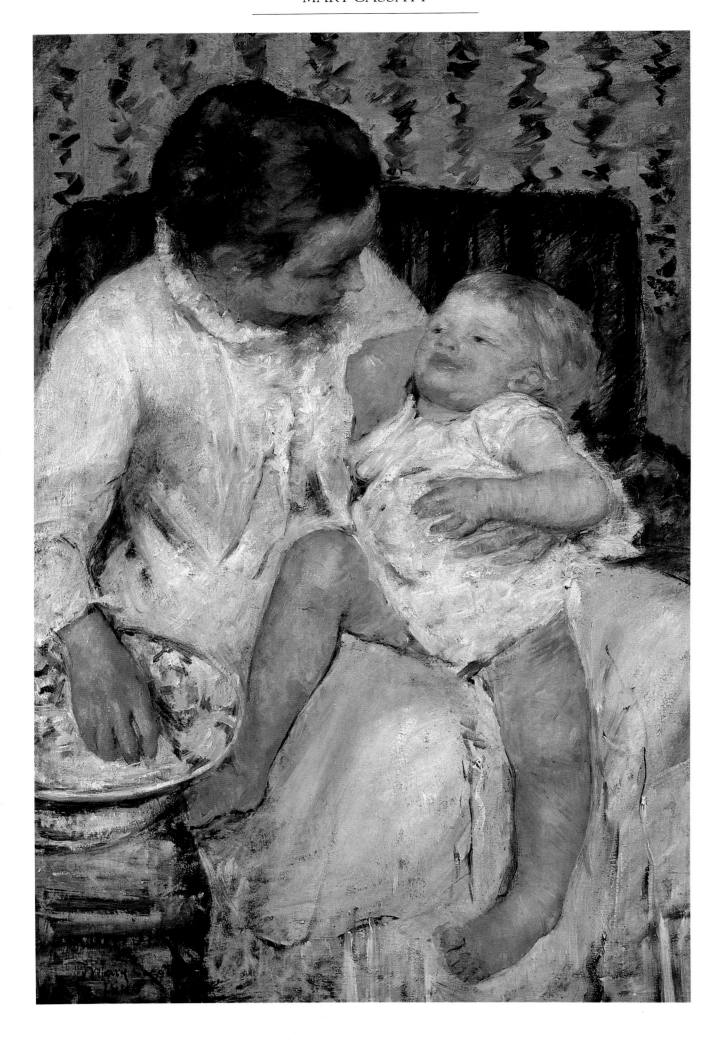

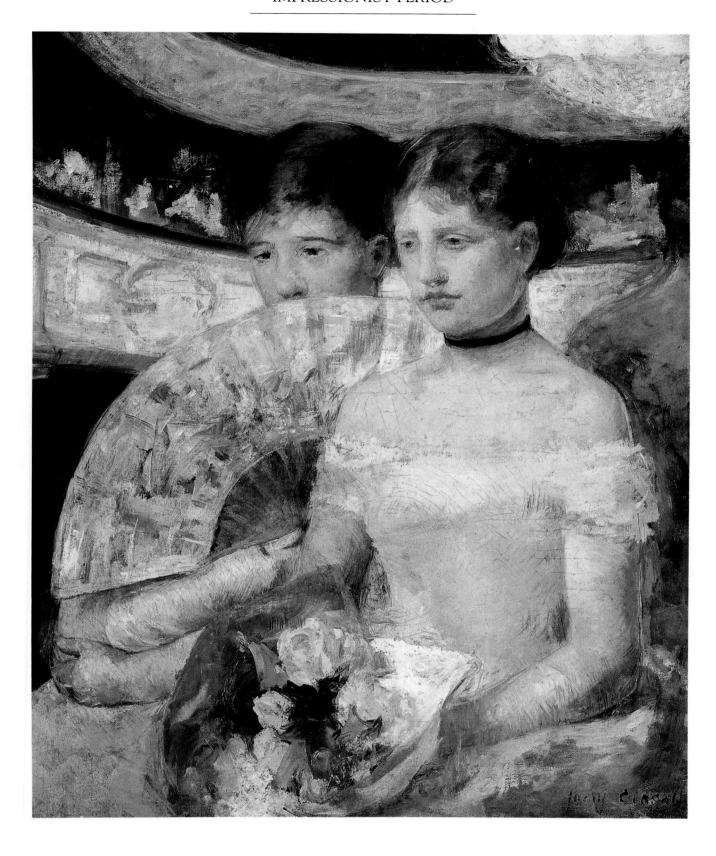

Left:
Mother About to Wash Her Sleepy Child
1880, oil on canvas, 39½×25¾ in.
Bequest of Mrs. Fred Hathaway Bixby,
Los Angeles County Museum of Art, CA
(M.62.8.14)

The Loge
1882, oil on canvas, 31×25⅛ in.
Chester Dale Collection,
National Gallery of Art, Washington, DC
(1963.10.96)

Little Girl in Blue Armchair
1878, oil on canvas, 35¼×51⅛ in.
Collection of Mr. and Mrs. Paul Mellon,
National Gallery of Art, Washington, DC
(1983.1.18)

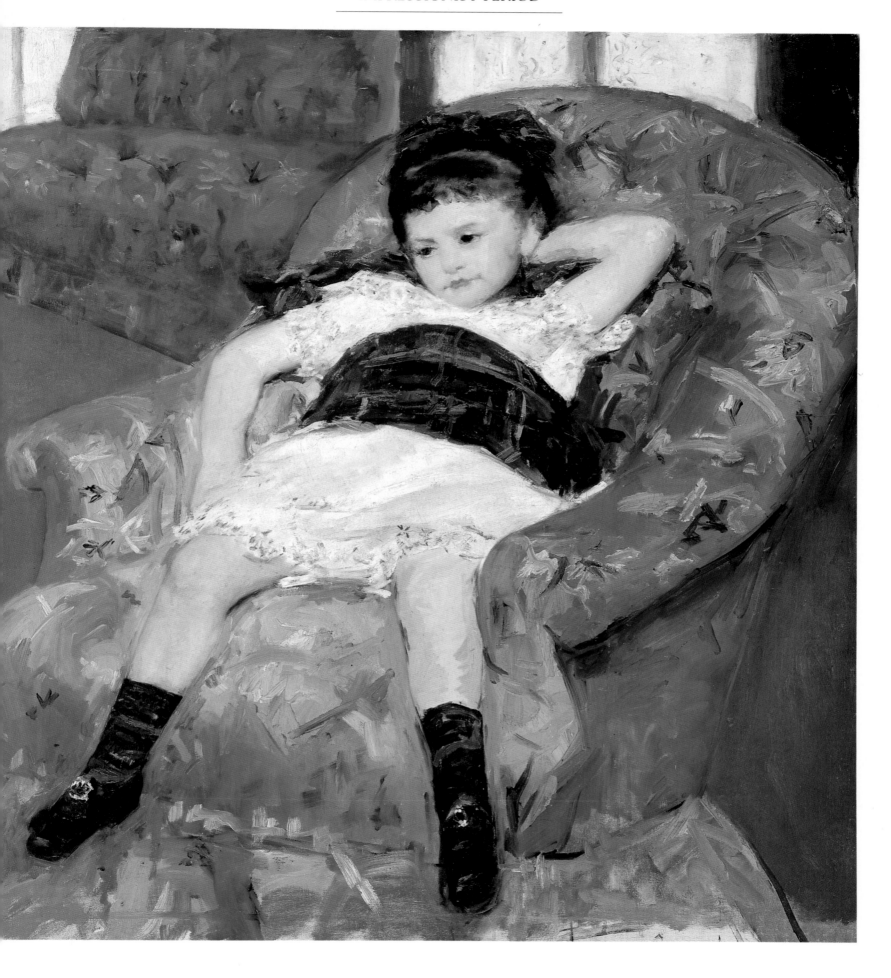

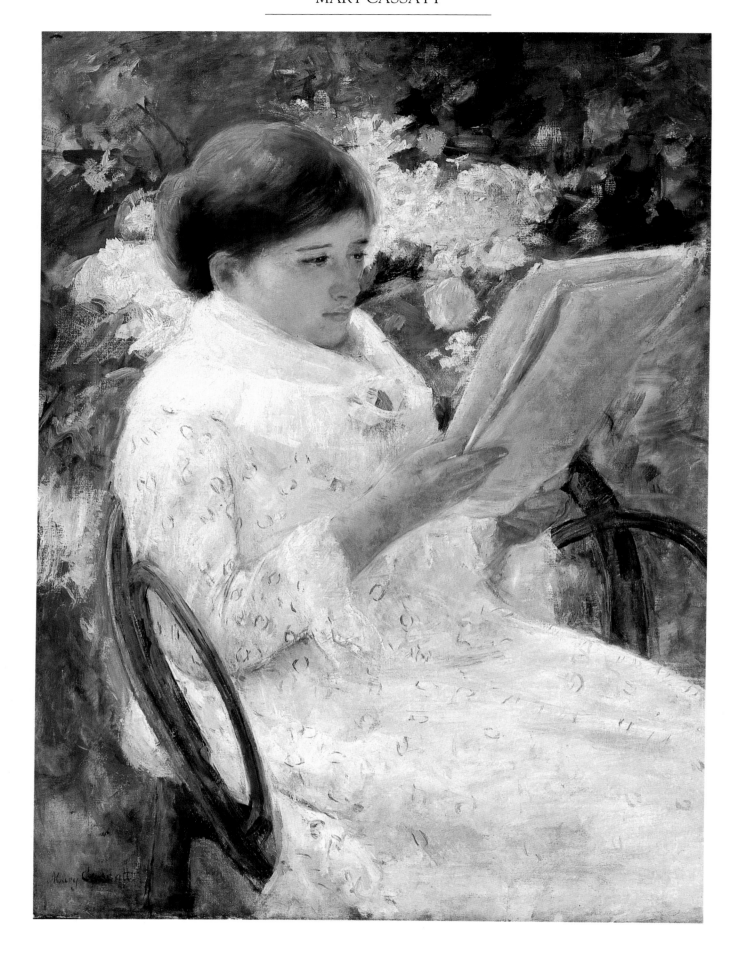

Woman Reading in a Garden
1880, oil on canvas, 35½×25⅝ in.
Gift of Mrs. Albert J. Beveridge in memory
of her aunt, Delia Spencer Field,
© *1988 The Art Institute of Chicago, IL*
All Rights Reserved
(1938.18)

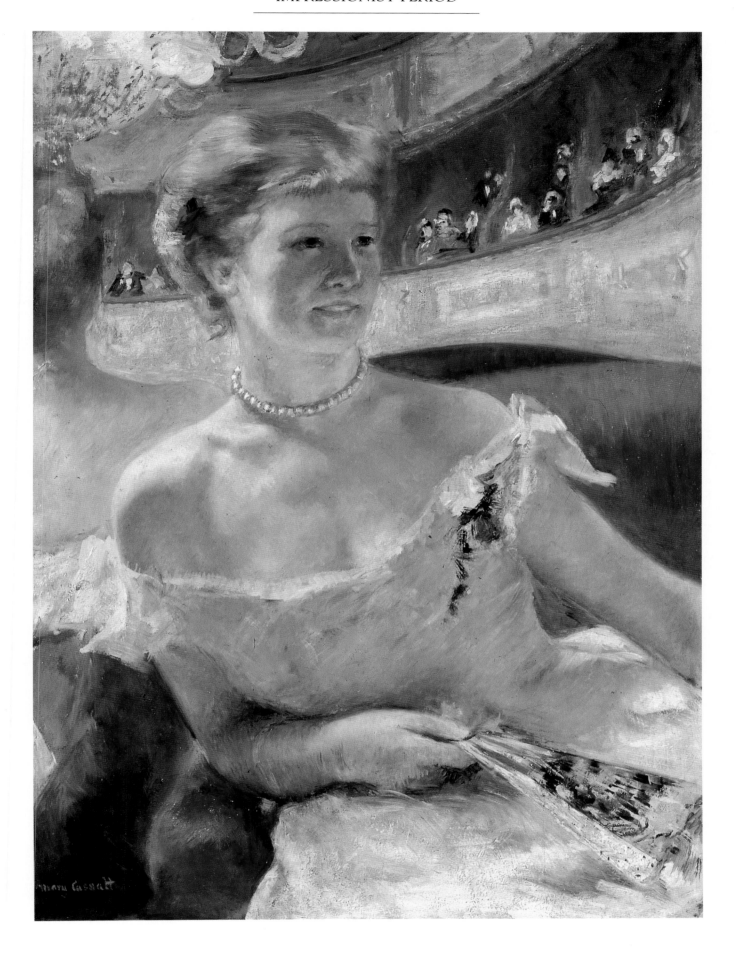

Woman with a Pearl Necklace in a Loge
1879, oil on canvas, 31⅝×23 in.
Bequest of Charlotte Dorrance Wright,
Philadelphia Museum of Art, PA
(1978-1-5)

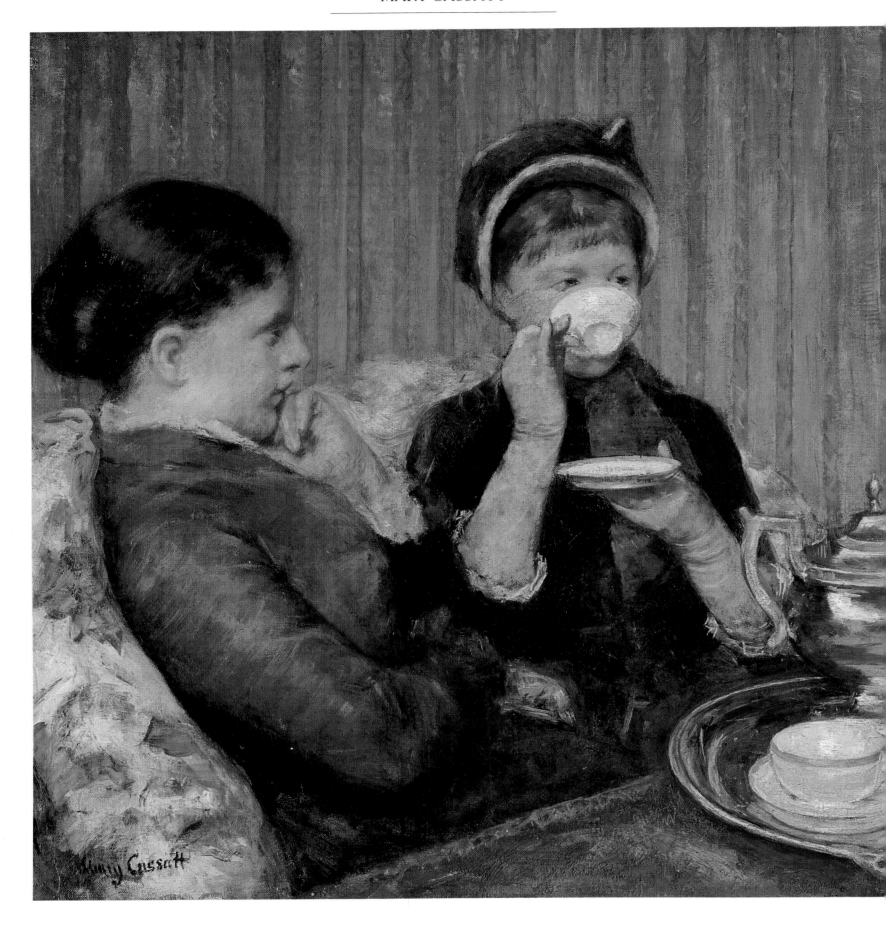

Five O'Clock Tea
1880, oil on canvas, 25½×36½ in.
M. *Theresa B. Hopkins Fund,*
Courtesy, Museum of Fine Arts, Boston,
MA
(42.178)

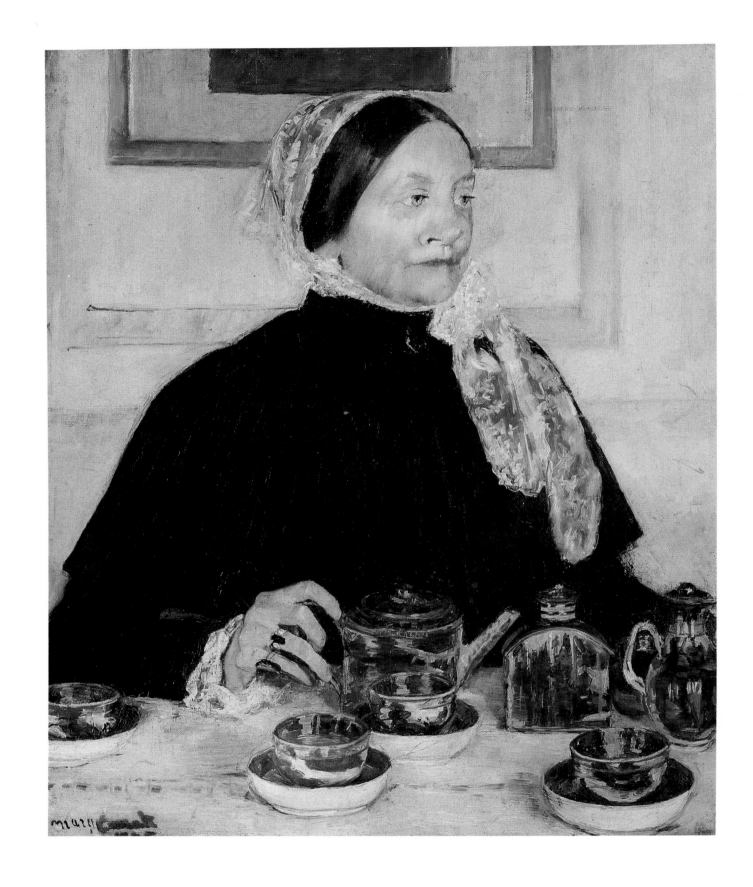

Lady at the Tea Table
1885, oil on canvas, 29×24 in.
Gift of the artist, 1923,
The Metropolitan Museum of Art, New
York, NY
(23.101)

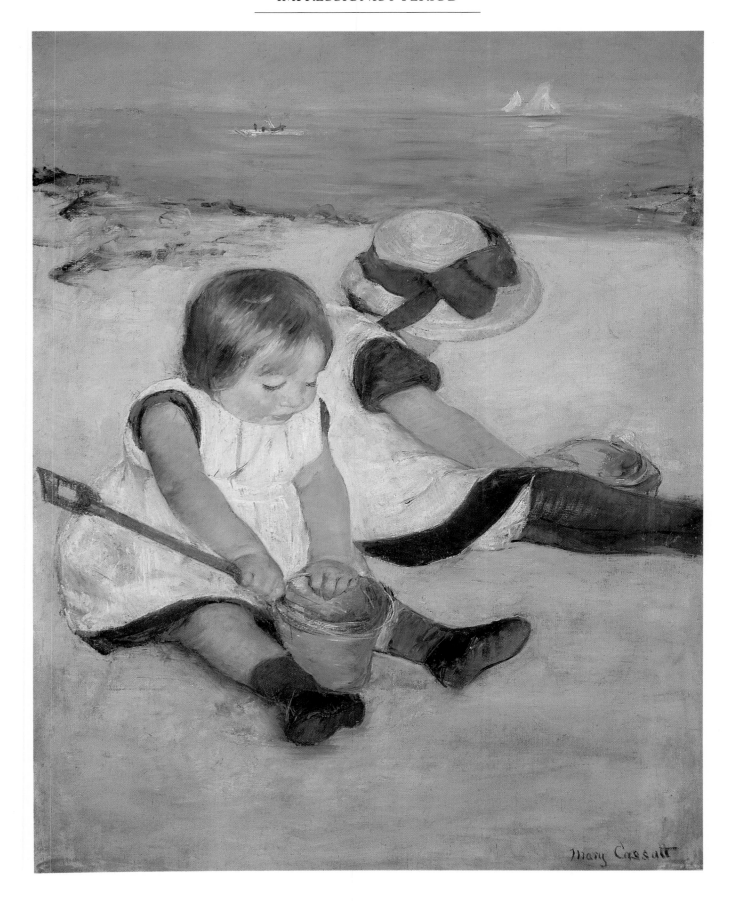

Children Playing on the Beach
1884, oil on canvas, 38⅜×29¼ in.
Ailsa Mellon Bruce Collection,
National Gallery of Art, Washington, DC
(1970.17.19)

Lydia at a Tapestry Frame
c. 1881, oil on canvas, 25¾×36¼ in.
Gift of The Whiting Foundation,
Flint Institute of Arts, MI
(67.32)

Child in a Straw Hat
c. 1886, oil on canvas, 25¾×19½ in.
Collection of Mr. and Mrs. Paul Mellon,
National Gallery of Art, Washington, DC
(1983.1.17)

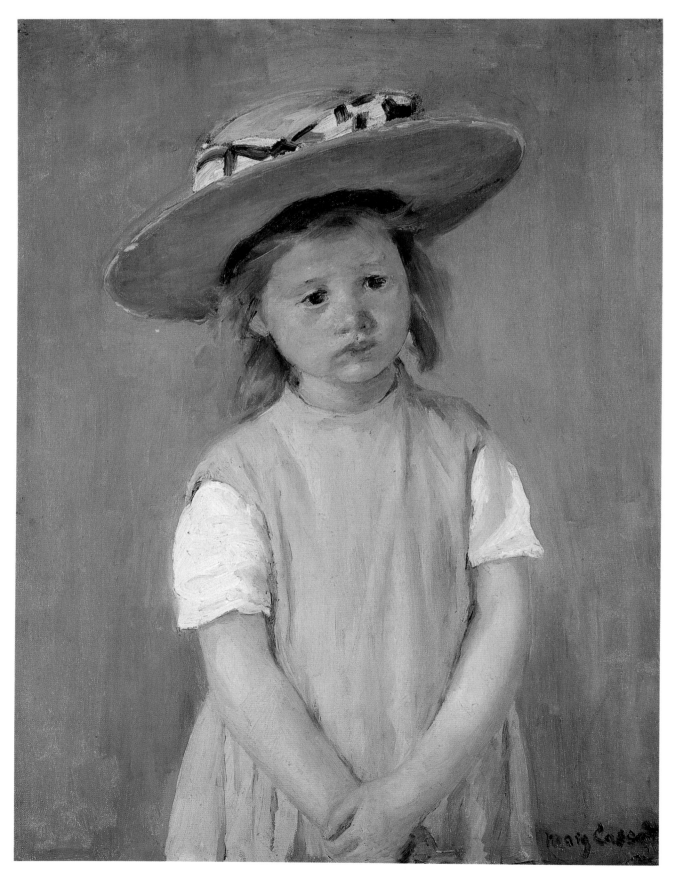

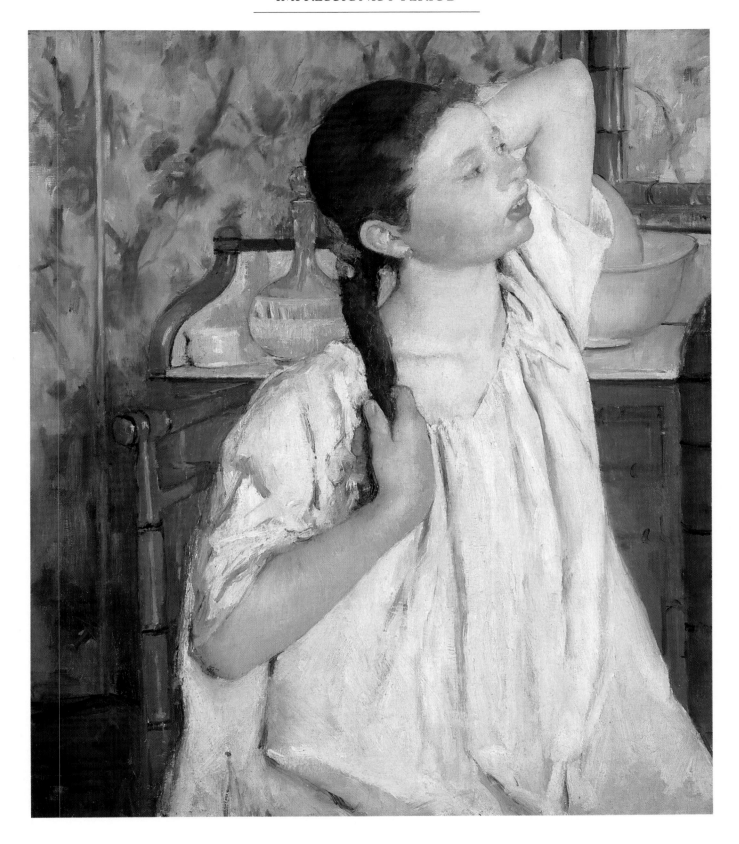

Girl Arranging Her Hair
1886, oil on canvas, 29½×24½ in.
Chester Dale Collection,
National Gallery of Art, Washington, DC
(1963.10.97)

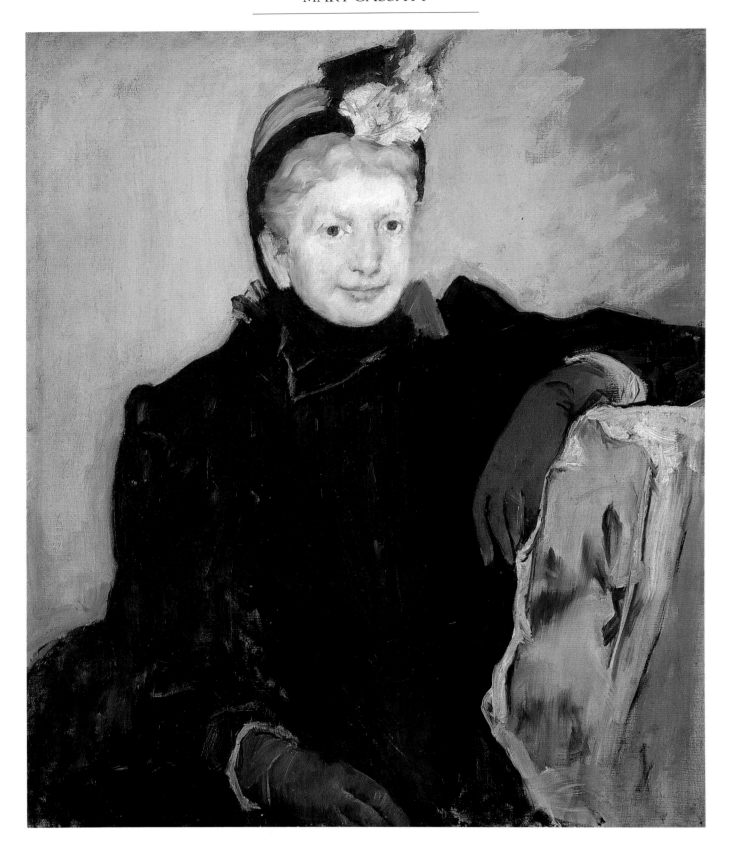

Portrait of an Elderly Lady
c. 1887, oil on canvas, 28⅝ × 23¾in.
Chester Dale Collection,
National Gallery of Art, Washington, DC
(1963.10.7)

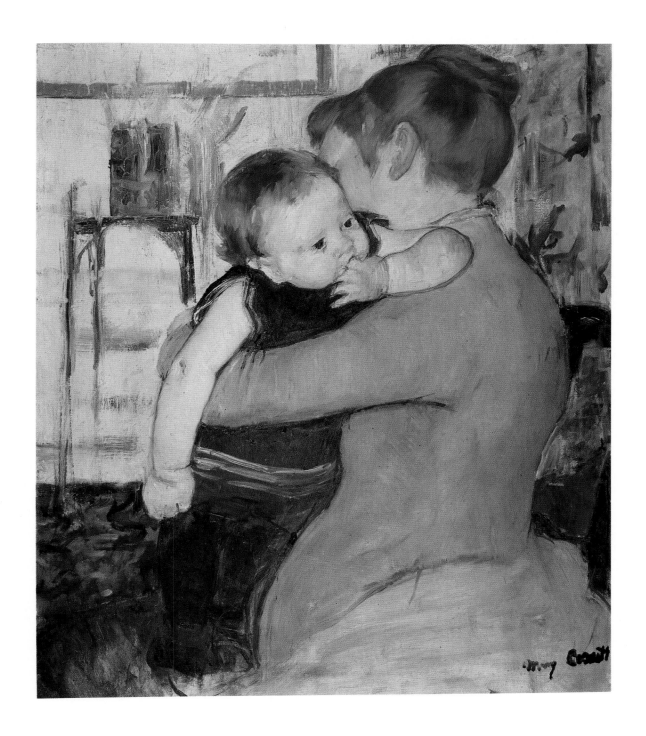

Mother and Child
1889, oil on canvas, 29×23½ in.
John J. Emery Endowment,
Cincinnati Art Museum, OH
(1928.222)

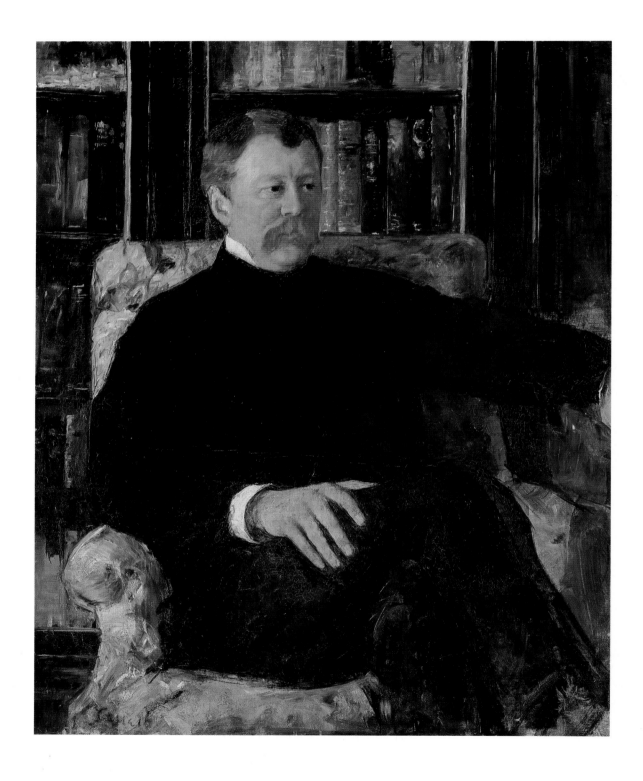

Portrait of Alexander Cassatt
1880, oil on canvas, 29½×32 in.
Private Collection

Right:
At the Opera
1880, Oil on canvas, 31½×25½ in.
Charles Henry Hayden Fund,
Courtesy, Museum of Fine Arts, Boston,
MA
(10.35)

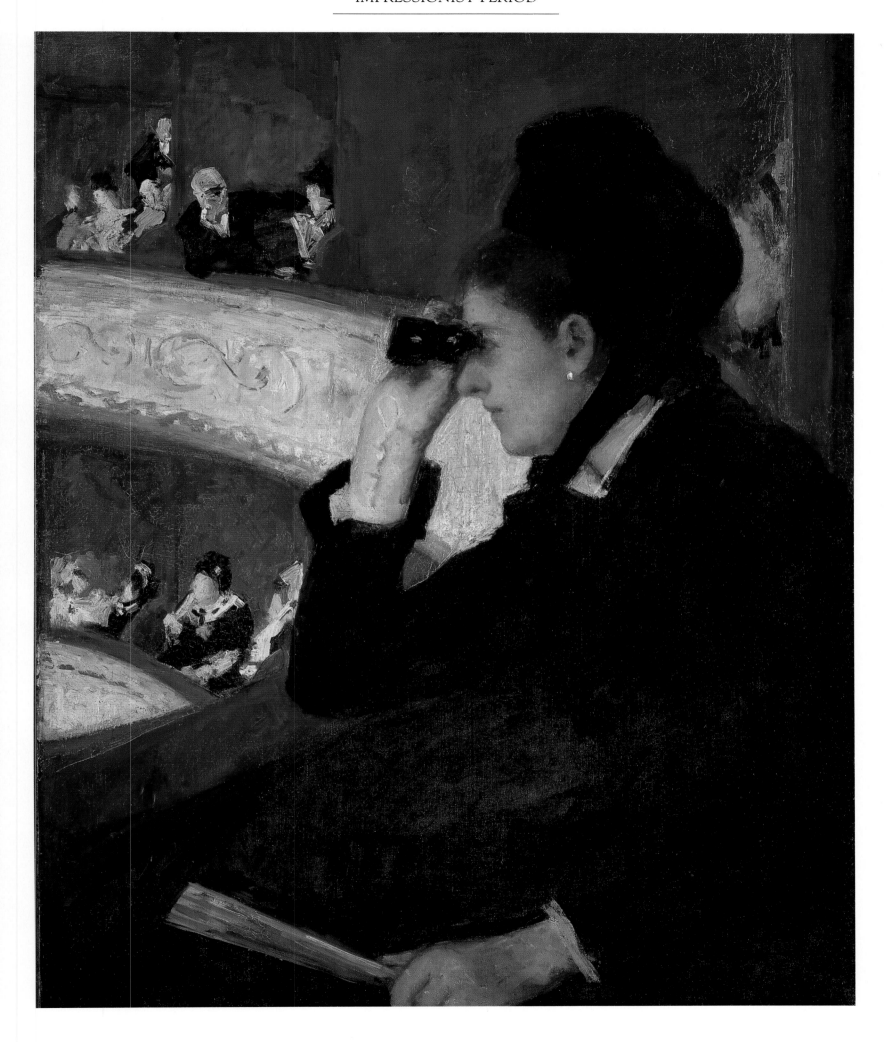

Susan Comforting the Baby No. 1
c. 1881, oil on canvas, 17×23 in.
Bequest of Frederick W. Schumacher,
The Columbus Museum of Art, OH
([57]54.4)

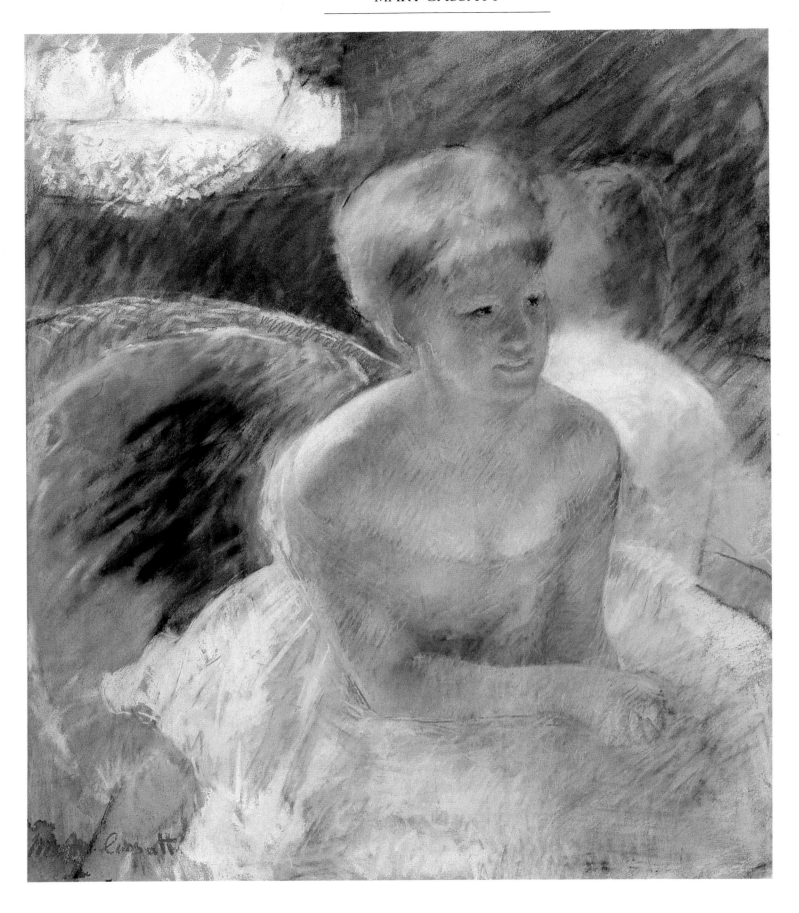

At the Theater (Woman in a Loge)
c. 1879, pastel on paper, 21¹³⁄₁₆×18⅛ in.
Anonymous gift,
The Nelson-Atkins Museum of Art, Kansas
City, MO

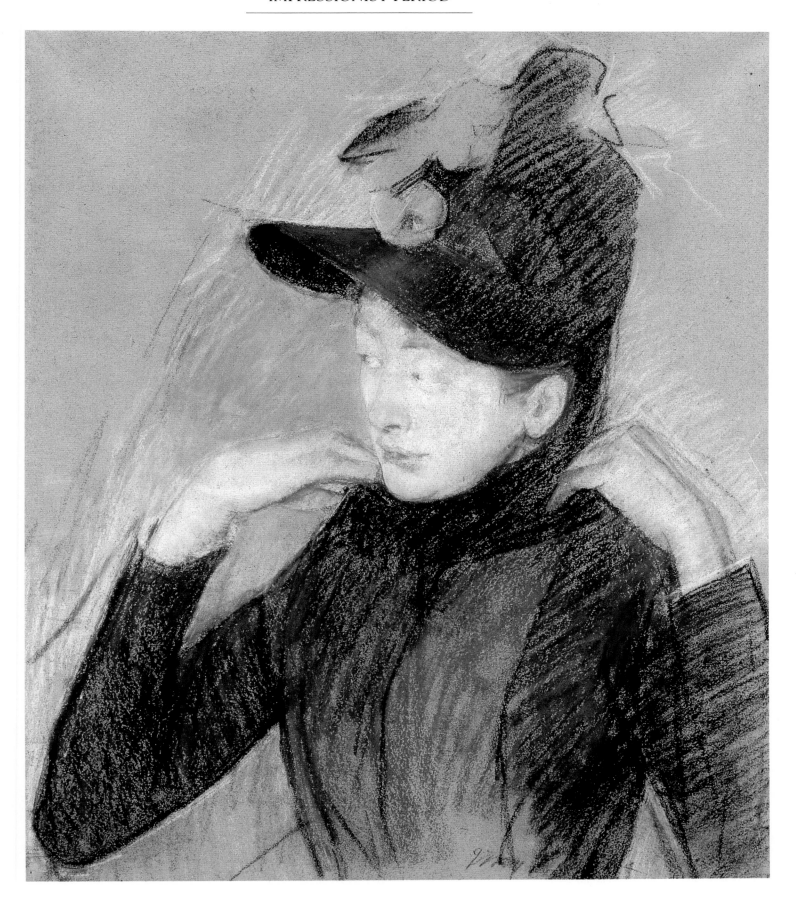

Woman Arranging Her Veil
c. 1890, pastel, 25½×21½ in.
Bequest of Lisa Norris Elkins,
Philadelphia Museum of Art, PA
('50-92-3)

Woman and Child Driving
1881, oil on canvas, 35¼×51½ in.
W.P. Wilstach Collection,
Philadelphia Museum of Art, PA
(W'21-1-1)

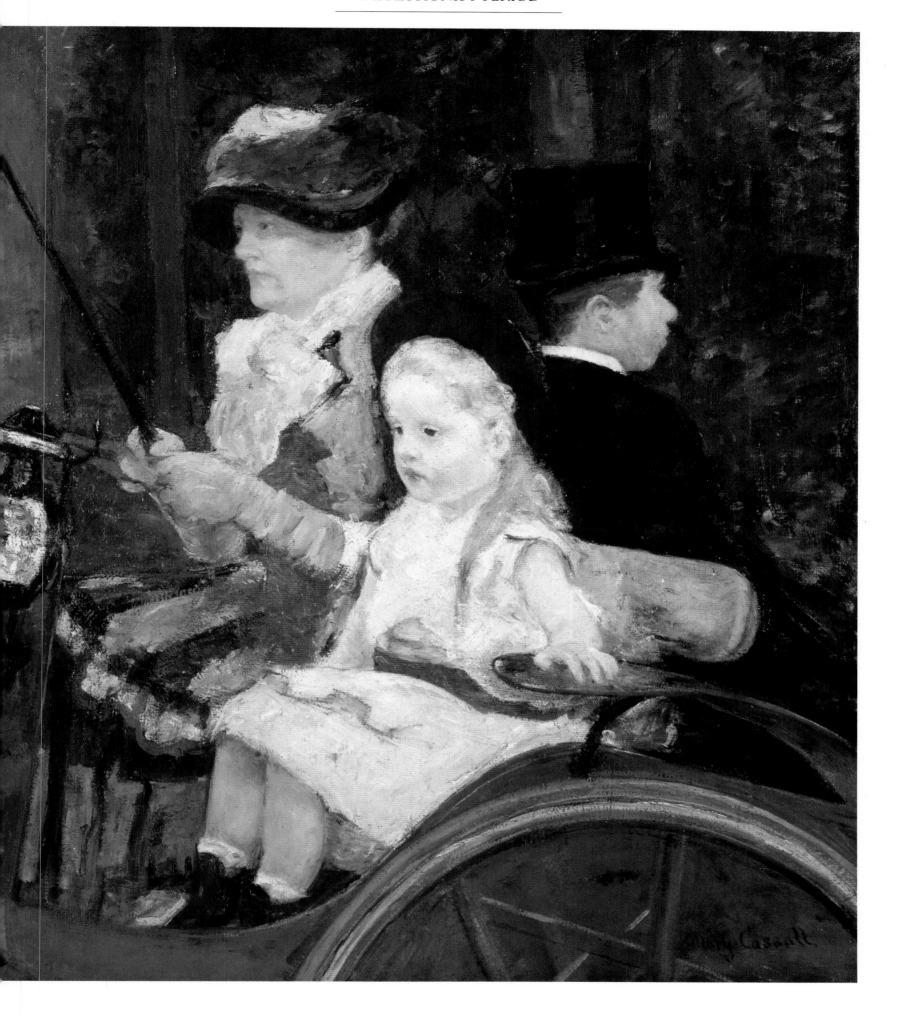

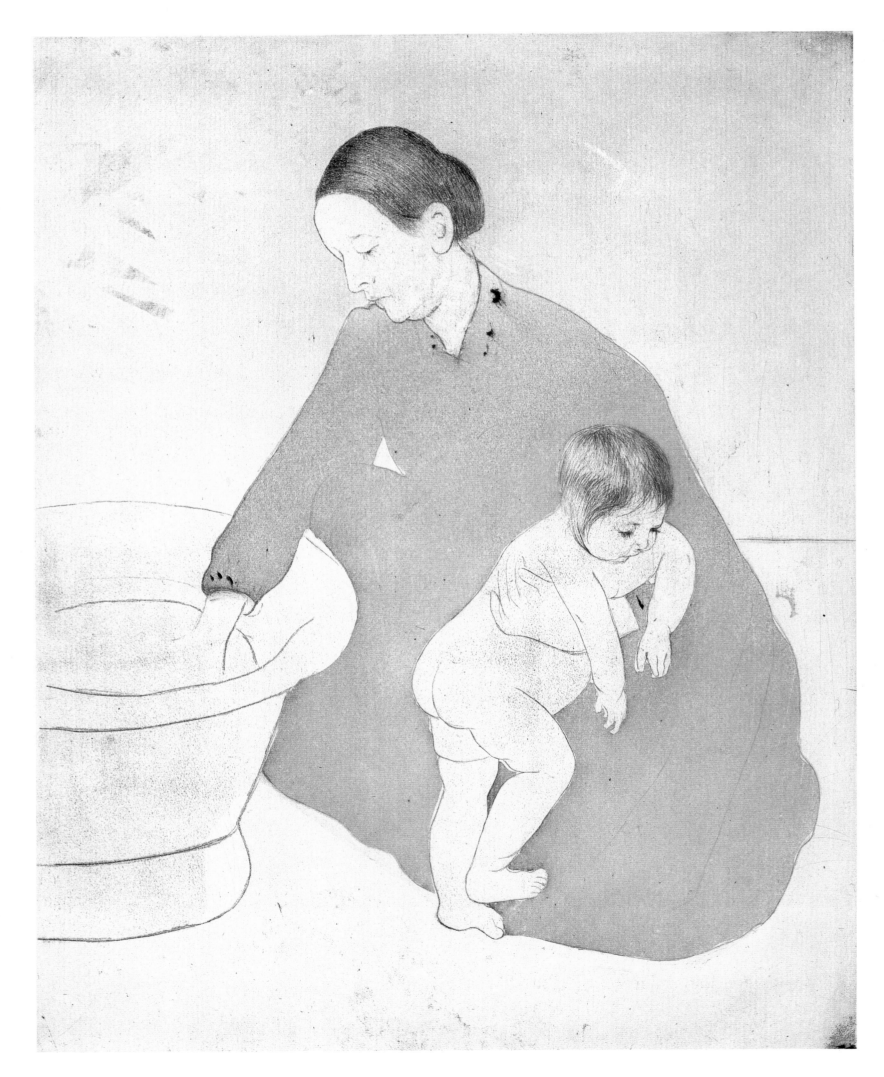

THE MATURE
PERIOD

If the first three decades of Mary Cassatt's career were largely shaped by outside influences – art school in the 1860s, the old realist masters in the 1870s and the French Impressionists in the 1880s – the decade of the 1890s marks a period when her unique creativity and individual style at last emerged unfettered.

Her continuing emphasis on controlled brushwork and form prompted her to experiment with new media that would create a more linear effect. The drypoint technique, which involves scratching a sharp needle on a metal surface from which prints are made, suited her needs perfectly, and she produced over a hundred of these delicate, carefully-wrought works. It was an exacting art, of which Cassatt said, "In dry point you are down to the bare bones, you can't cheat."

Once she had perfected the drypoint technique Cassatt began to work in soft-ground etching, which also required decisive draftsmanship. And then she embarked on yet another new venture that placed her at the forefront of the new graphic arts movement in Paris. She began to work in aquatint, which combines one or both of the other techniques, and produced a series of 10-color prints that stunned the art world.

Cassatt, like many of her contemporaries, was also strongly attracted to the Japanese art that had begun to flow out of that country in the late nineteenth century. She was one of the first to imitate successfully this Japanese style, and her contemporaries were duly impressed. "The tone even, subtle, delicate, without stains on seams: adorable blues, fresh rose etc . . . the result is admirable, as beautiful as Japanese work, and it's done with printer's ink!" wrote Pissarro in a letter to his son. According to Cassatt, the first of these prints, *The Bath*, was her only

true imitation of Japanese art, and in subsequent prints such as *Mother's Kiss* and *The Lamp* she "tried more for atmosphere." She absorbed Japanese aesthetics so completely that they became incorporated into her personal style, as can be seen in her figures, who stand out against their backgrounds in clear linear delineations, offset by broad flat patterns.

As the decade progressed Cassatt produced some of her best-known and most evolved work. Her famous painting *The Bath*, of the same name and Japanese influence as her print, received critical acclaim and was followed by the nearly as celebrated *The Boating Party*, which reflects a new interest in outdoor scenes inspired by her visits to the south of France. Throughout, Cassatt continued to exploit the theme of mothers and children. For some of her models she chose members of her family and friends, as portrayed in *The Sailor Boy: Gardner Cassatt*. But her preferred subjects were simple peasant people, as depicted in *The Banjo Lesson* and *Baby's First Caress*, because she found them more unselfconsciously involved in the care of their children and therefore warmer and more spontaneous than many people who moved in her own circles.

As the century was coming to a close, and Cassatt was entering her fifties, she began to work almost exclusively in pastel. The result was a softer and more decorative approach, as in such works as *Three Women Admiring a Child* and *Mother Giving a Drink to Her Child*, and there is often more movement, as well. She produced prodigious quantities of work during these years, perhaps to make up for lost time but more probably because she was at the height of her creativity and had at last achieved that quality in her work that she had struggled so long to attain – complete individuality.

The Bath
c. 1891, drypoint and soft-ground etching
in black, yellow and blue, 16¼×11⅜ in.
Rosenwald Collection,
National Gallery of Art, Washington, DC
(1943.3.2735)

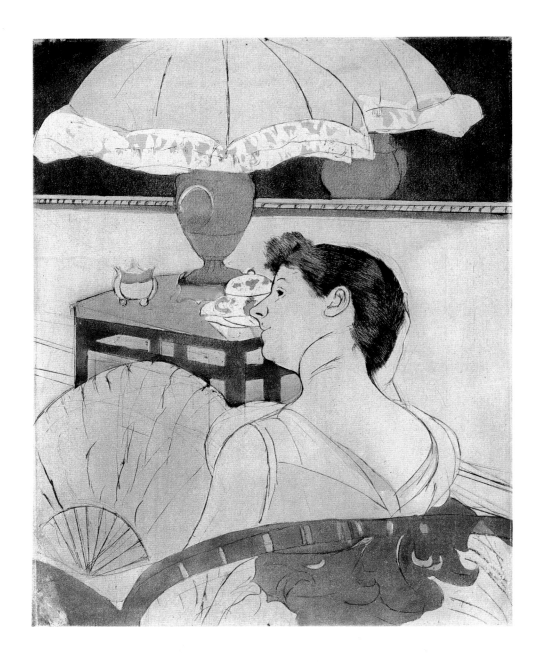

The Lamp
c. 1891, drypoint, soft-ground etching and
aquatint in color, 17¼ × 12 in.
Rosenwald Collection,
National Gallery of Art, Washington, DC
(1943.3.2762)

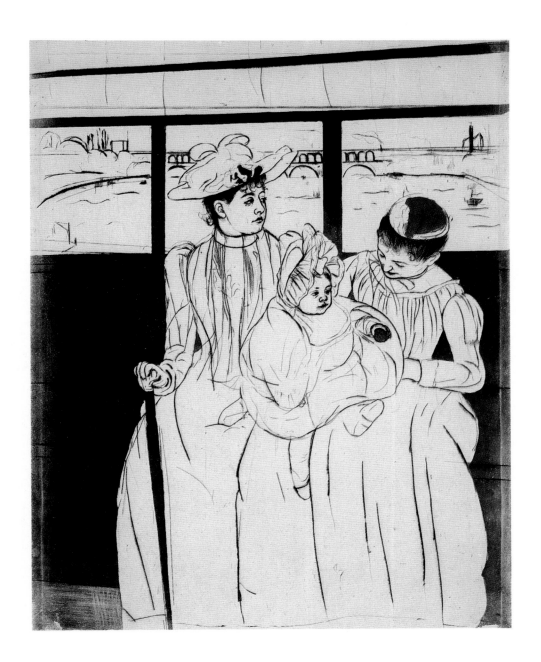

In the Omnibus
c. 1891, drypoint, soft-ground etching and
aquatint in black,
14⁷⁄₁₆×10⁹⁄₁₆ in.
Rosenwald Collection,
National Gallery of Art, Washington, DC
(1943.3.2752)

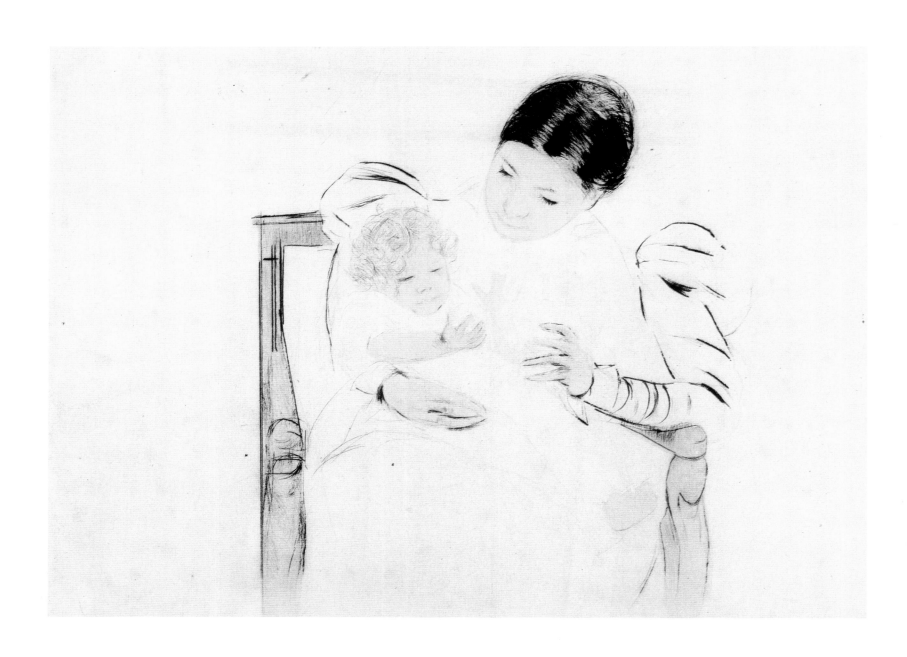

The Barefooted Child
1898, color drypoint and aquatint,
9⅝×12¾ in.
Gift of Mrs. Horace Binney Hare,
Philadelphia Museum of Art
('56-113-15)

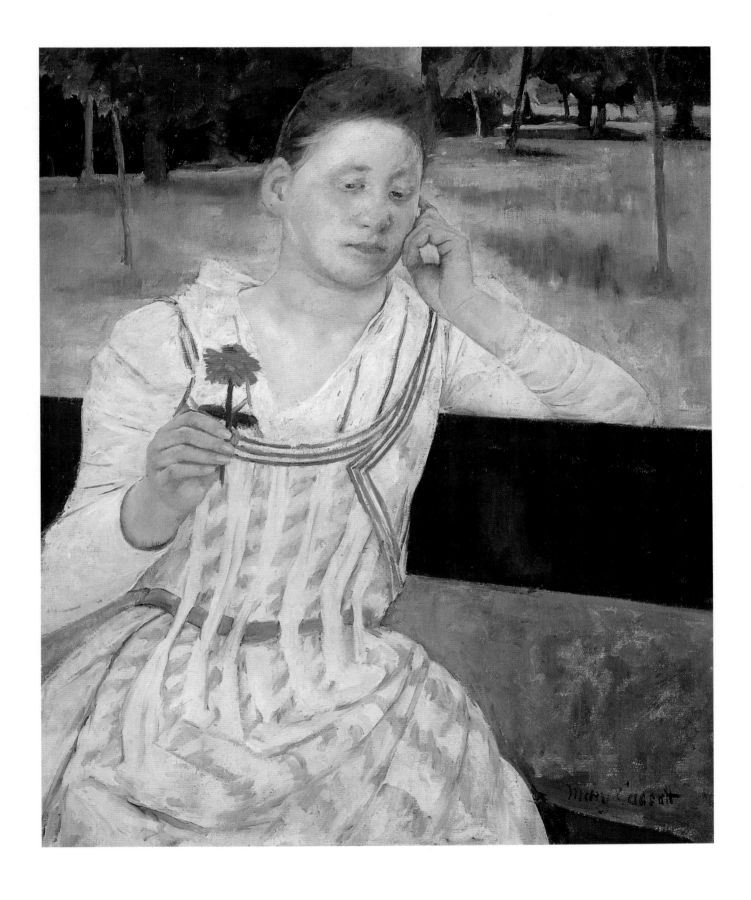

Woman with a Red Zinnia
1891, oil on canvas, 29×23¾ in.
Chester Dale Collection,
National Gallery of Art, Washington, DC
(1963.10.99)

Nurse Reading to a Little Girl
1895, pastel on paper, 23¾×27⅞ in.
Gift of Mrs. Hope Williams Read, 1962,
The Metropolitan Museum of Art, New
York, NY
(62.72)

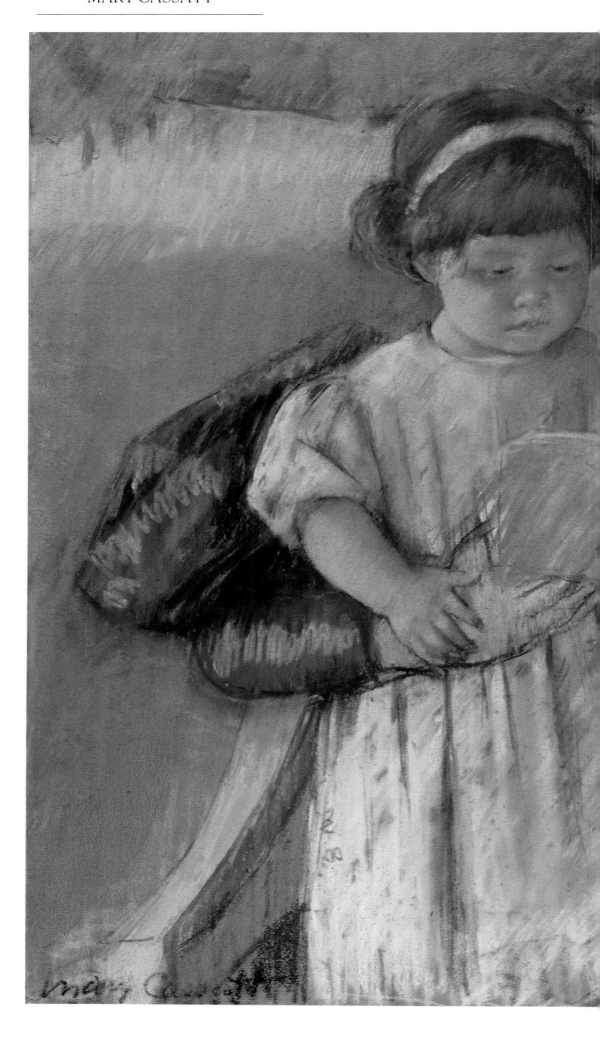

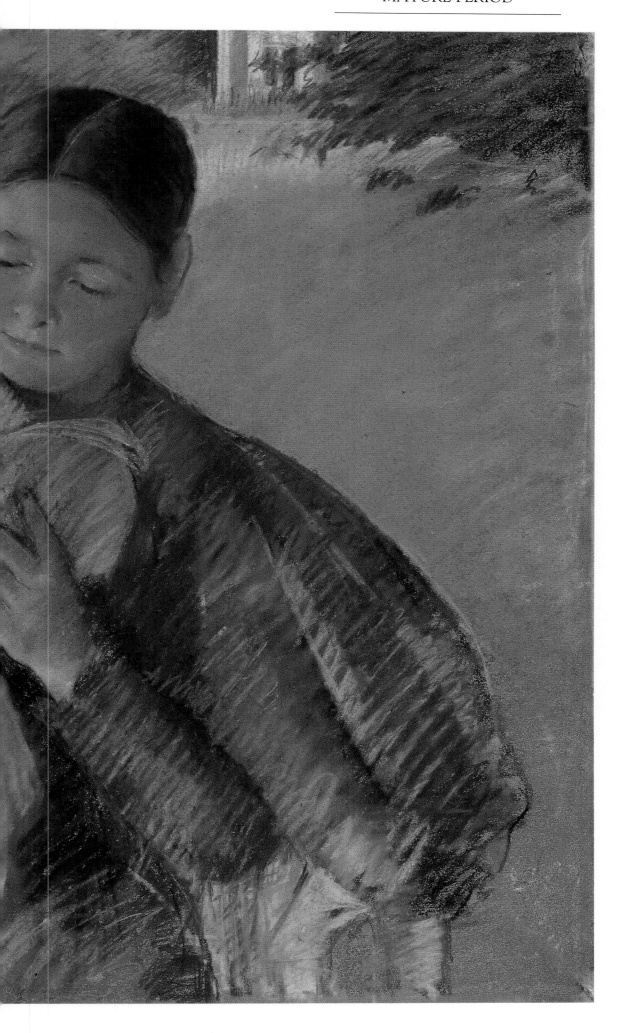

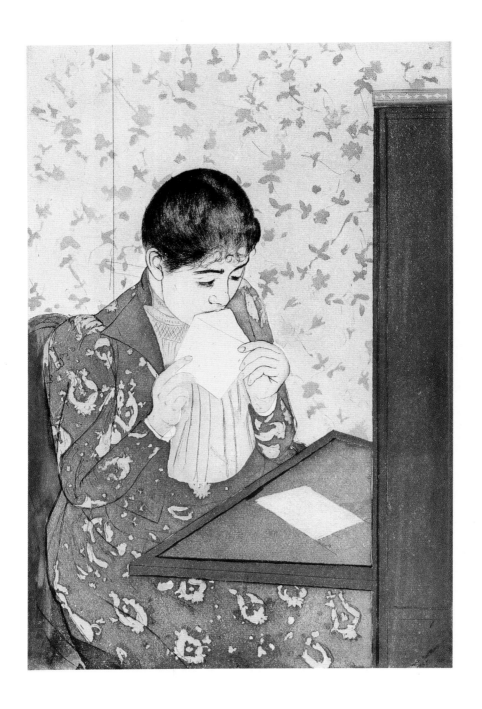

The Letter
c. 1891, drypoint, soft-ground etching and
aquatint in color,
18¹³⁄₁₆×12⅛ in.
Rosenwald Collection,
National Gallery of Art, Washington, DC
(1943.3.2763)

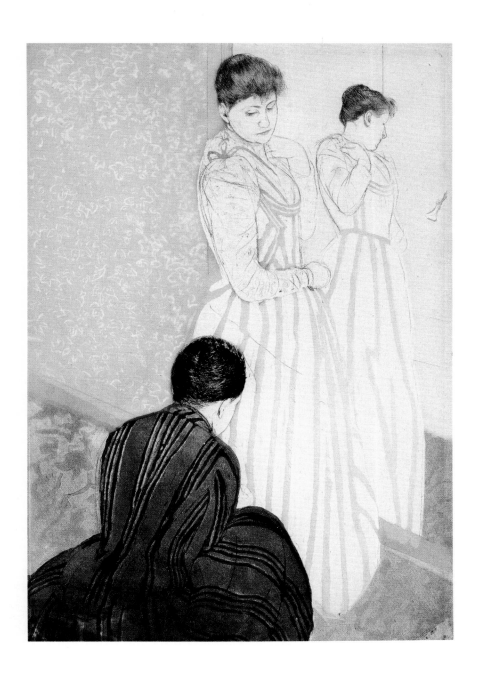

The Fitting
1891, drypoint and soft-ground etching in
color,
14¾×10¹⁄₁₆ in.
Chester Dale Collection,
National Gallery of Art, Washington, DC
(1963.10.252)

By the Pond
c. 1898, color aquatint, 13×16¾ in.
Gift of R. Sturgis Ingersoll,
Frederic Ballard, Alexander
Cassatt, Staunton B. Peck and Mrs. William
Potter,
Philadelphia Museum of Art
('46-11-7)

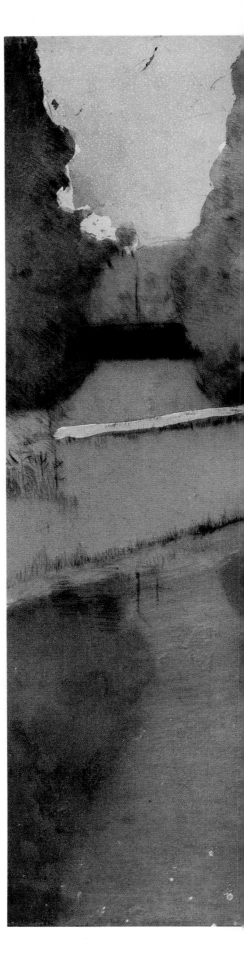

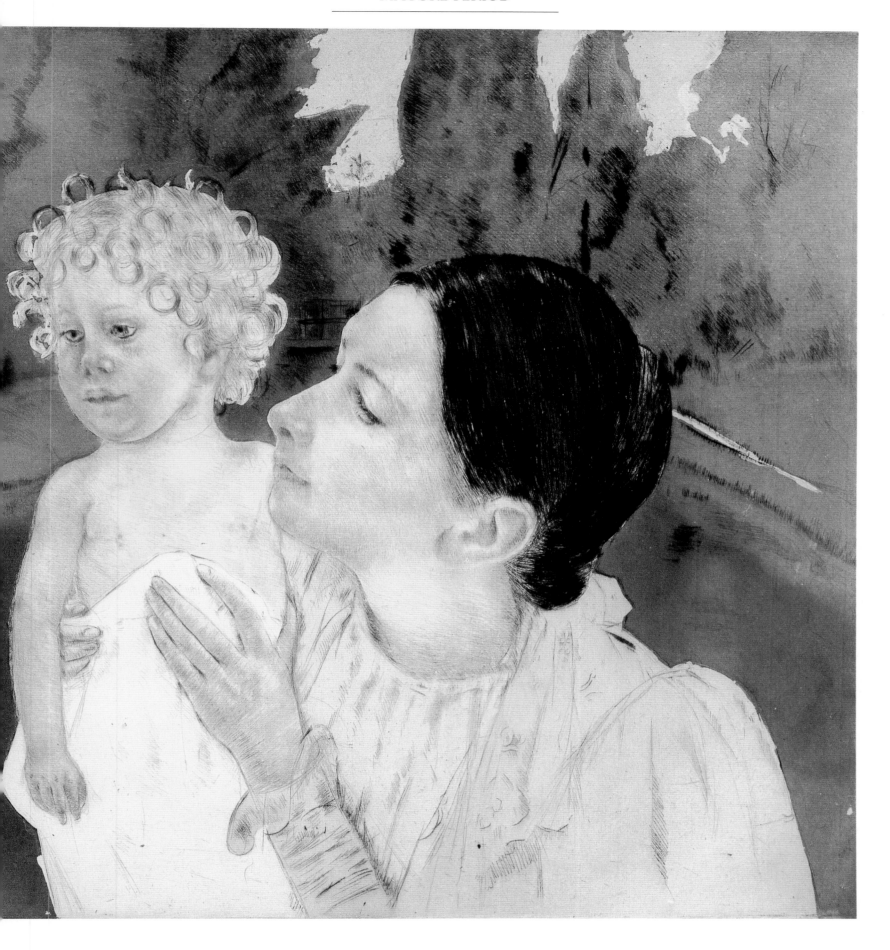

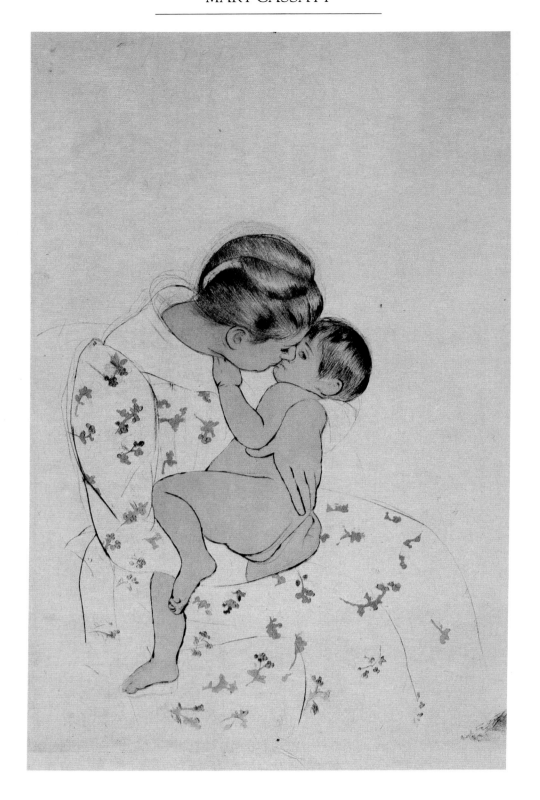

Mother's Kiss
c. 1891, drypoint and soft-ground etching
in color,
14⅝×10¾ in.
Rosenwald Collection,
National Gallery of Art, Washington, DC
(1943.3.2751)

Right:
In the Garden
1893, pastel, 28¾×25⅝ in.
The Cone Collection, formed by Dr. Claribel
Cone and Miss Etta Cone of Baltimore,
Maryland,
The Baltimore Museum of Art, MD
(BMA 1950.193)

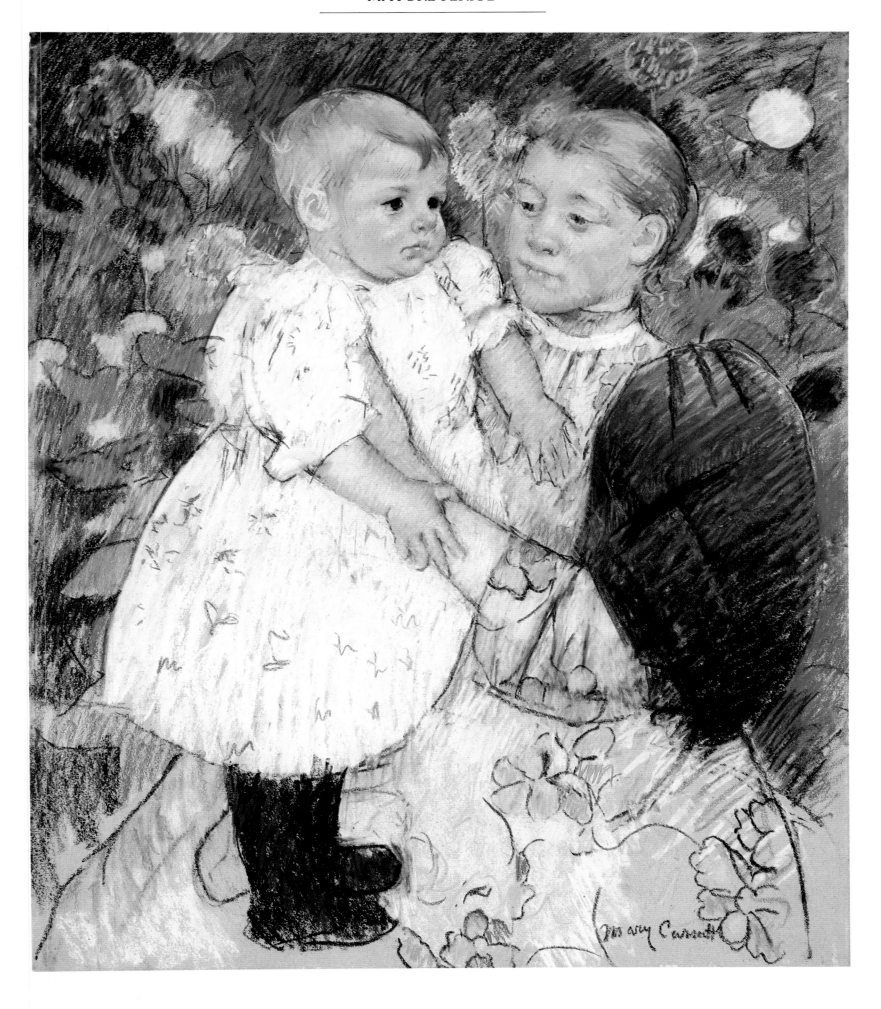

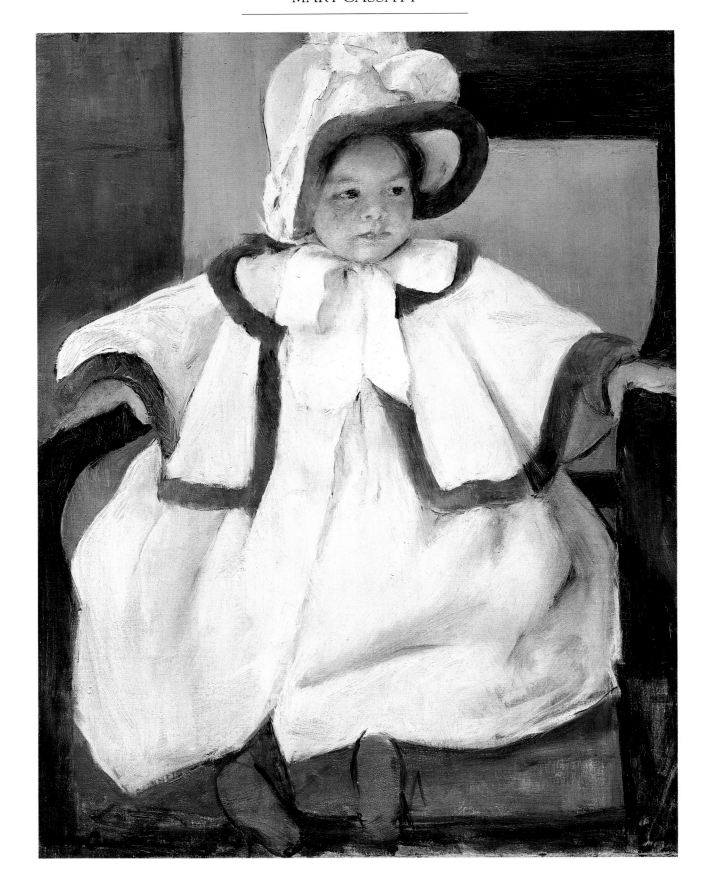

Ellen Mary Cassatt in a White Coat
c. 1896, oil on canvas, 32¼×24 in.
Anonymous fractional gift in Honor of Ellen
Mary Cassatt,
Museum of Fine Arts, Boston, MA
(1982.630)

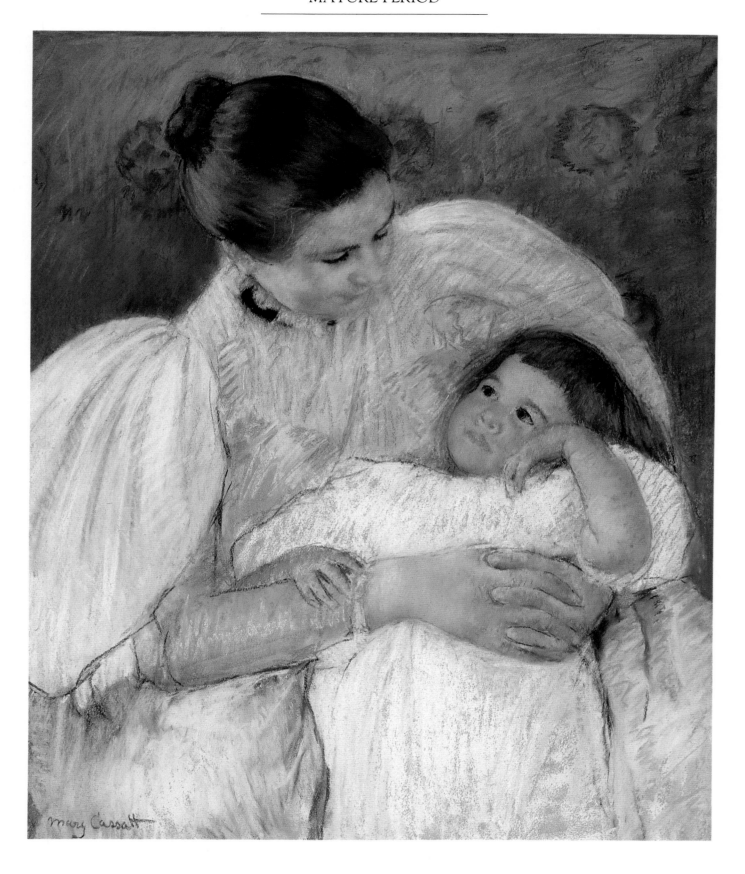

Nurse and Child
1896-97, pastel on paper, 31½×26¼ in.
Gift of Mrs. Ralph J. Hines, 1960,
The Metropolitan Museum of Art, New
York, NY
(60.181)

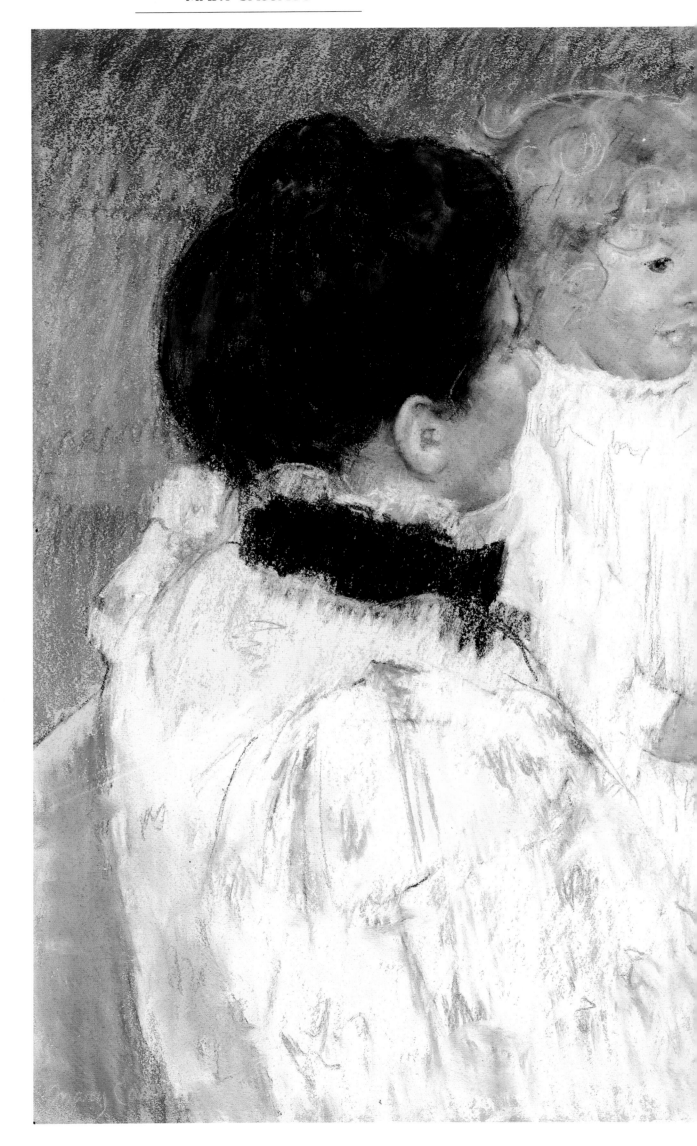

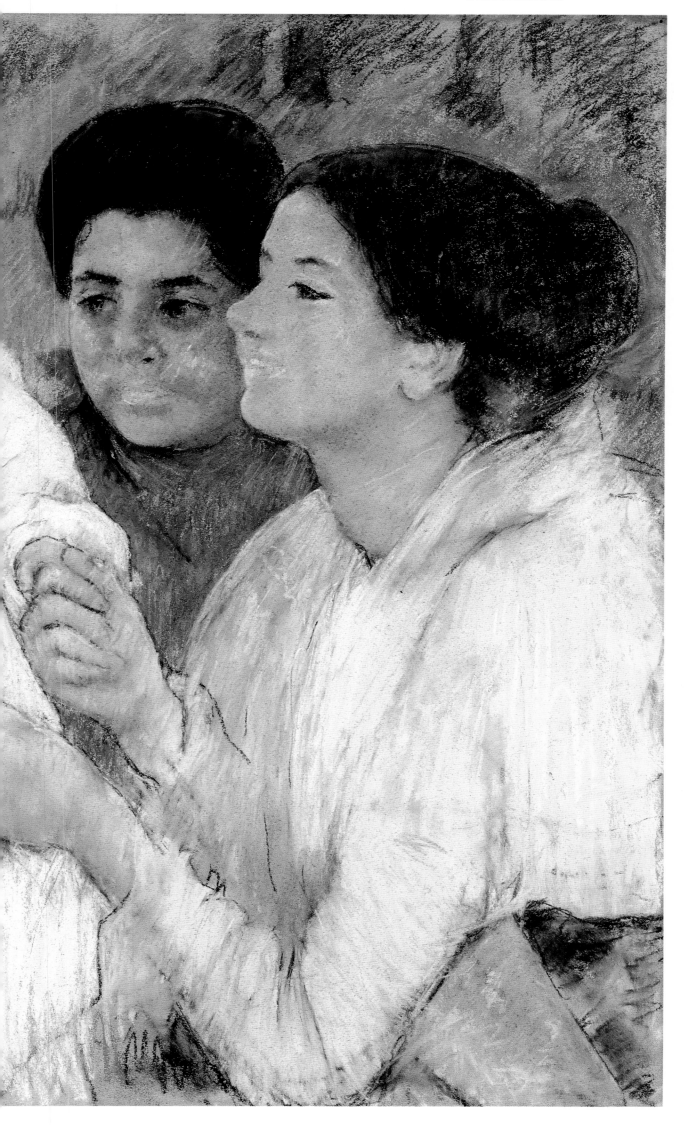

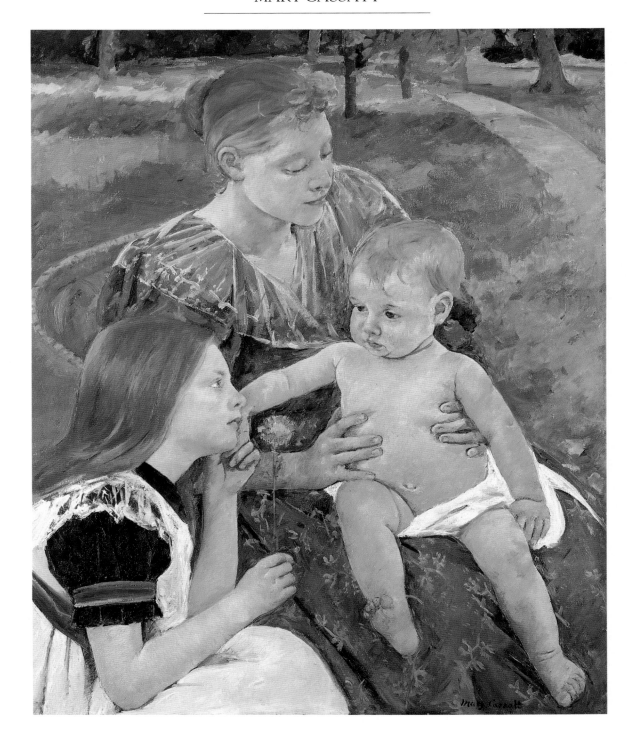

Pages 70-71:
Women Admiring a Child
1897, pastel on paper, 26×32 in.
Gift of Edward Chandler Walker,
© *Detroit Institute of Arts, MI*
(08.8)

The Family
c. 1892, oil on canvas, 32¼ × 26⅛ in.
The Chrysler Museum, Norfolk, VA
(71.498)

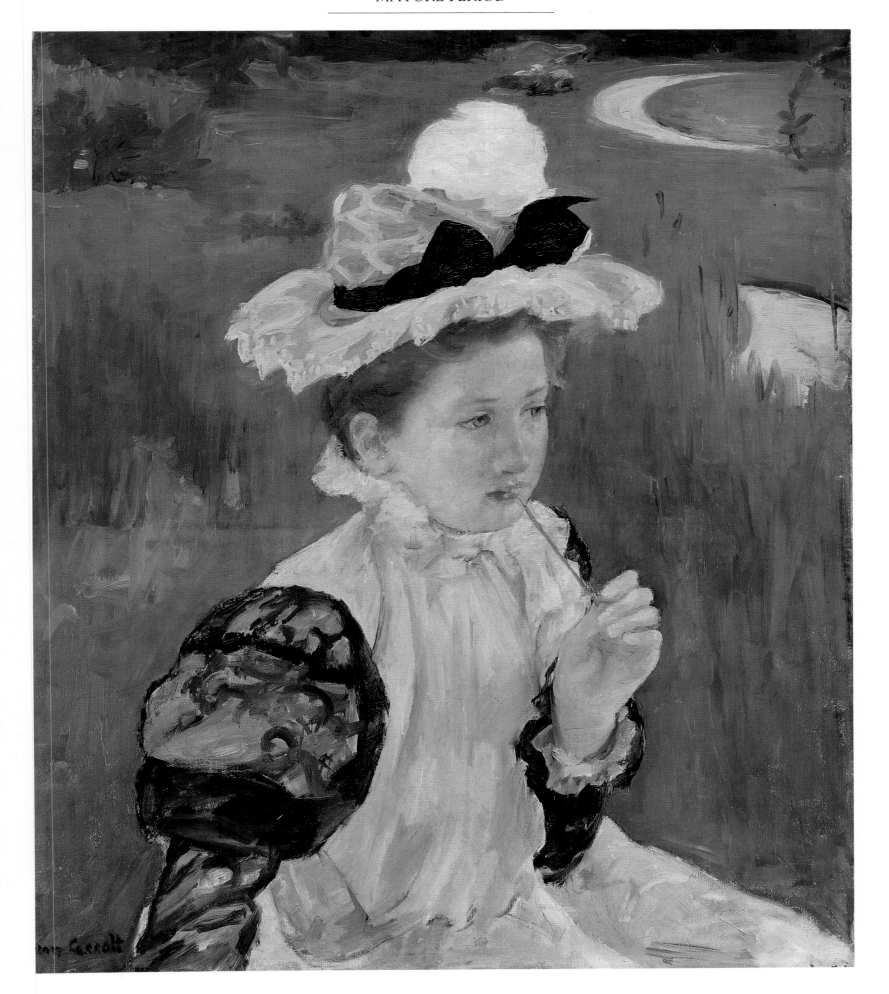

Portrait of a Young Girl
c. 1900, oil on canvas, 29×24⅛ in.
From the Collection of James Stillman, Gift
of Dr. Ernest G. Stillman, 1922,
The Metropolitan Museum of Art, New
York, NY
(22.16.18)

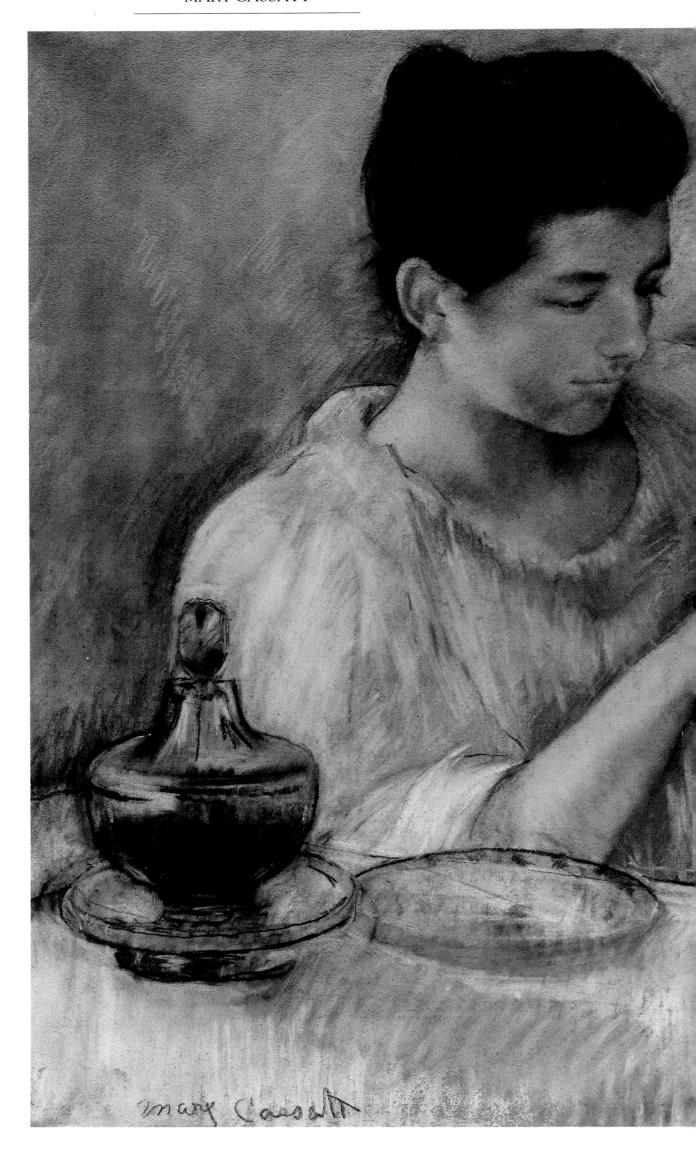

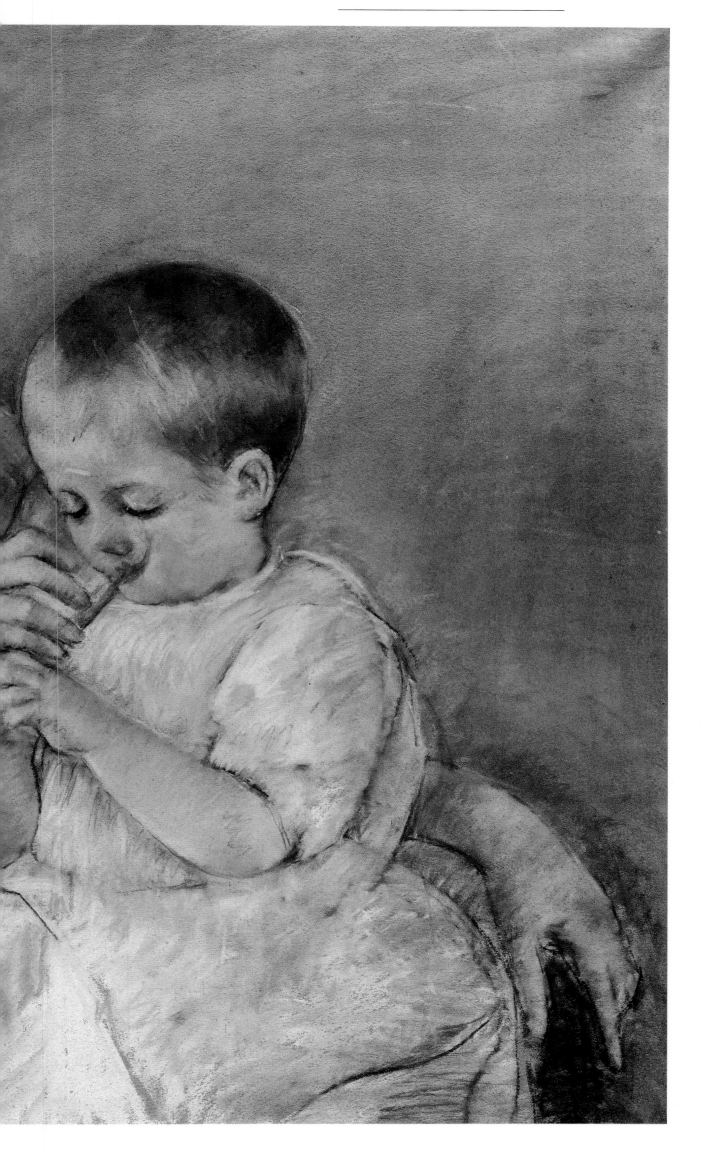

Young Women Picking Fruit
1891, oil on canvas, 51½×35½ in.
Patrons Art Fund, 1922,
The Carnegie Museum of Art, Pittsburgh,
PA

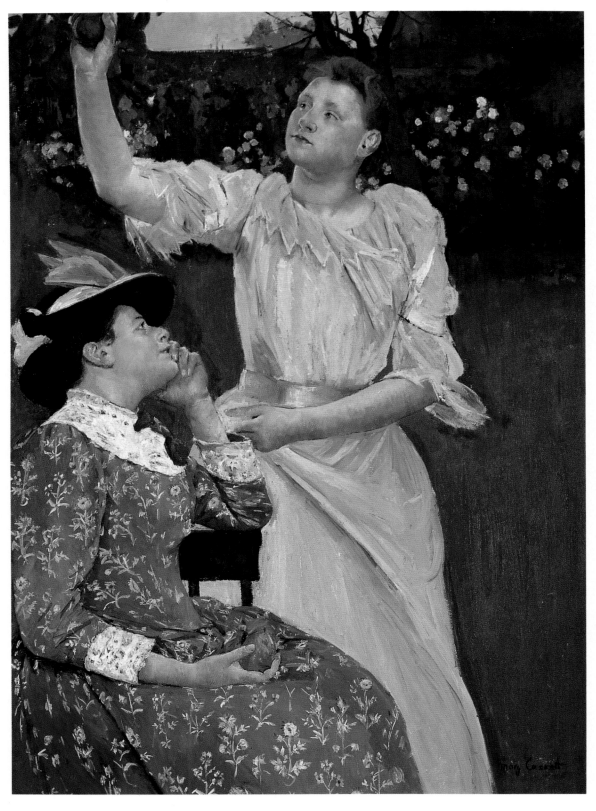

Pages 74-75:
Mother Feeding Her Child
1898, pastel, 25½×32 in.
From the Collection of James Stillman, gift of
Dr. Ernest G. Stillman, 1922,
The Metropolitan Museum of Art, New
York, NY
(22.16.22)

Right:
Baby Reaching for an Apple
1893, oil on canvas, 39½×25¾ in.
Gift of an anonymous donor,
Virginia Museum of Fine Arts, Richmond,
VA

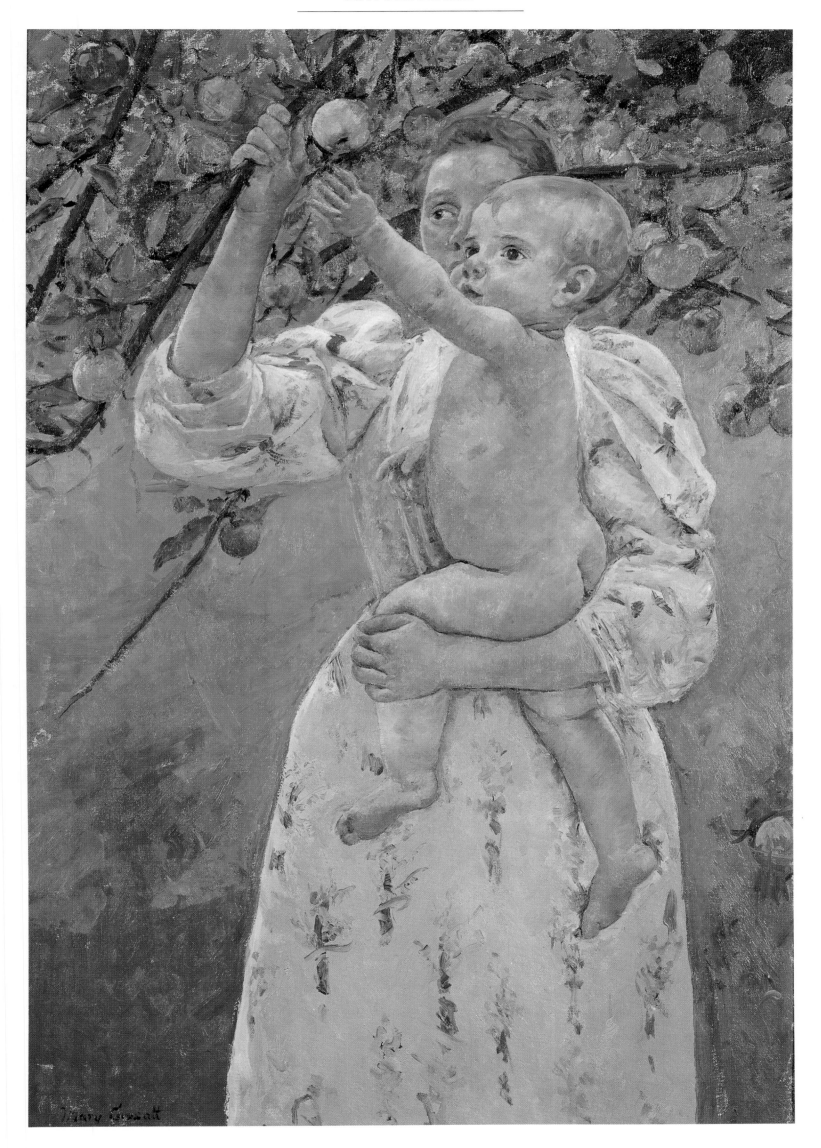

Maternal Caress
c. 1896, oil on canvas, 15×21¼ in.
Gift of Aaron Carpenter,
Philadelphia Museum of Art, PA
('70-75-2)

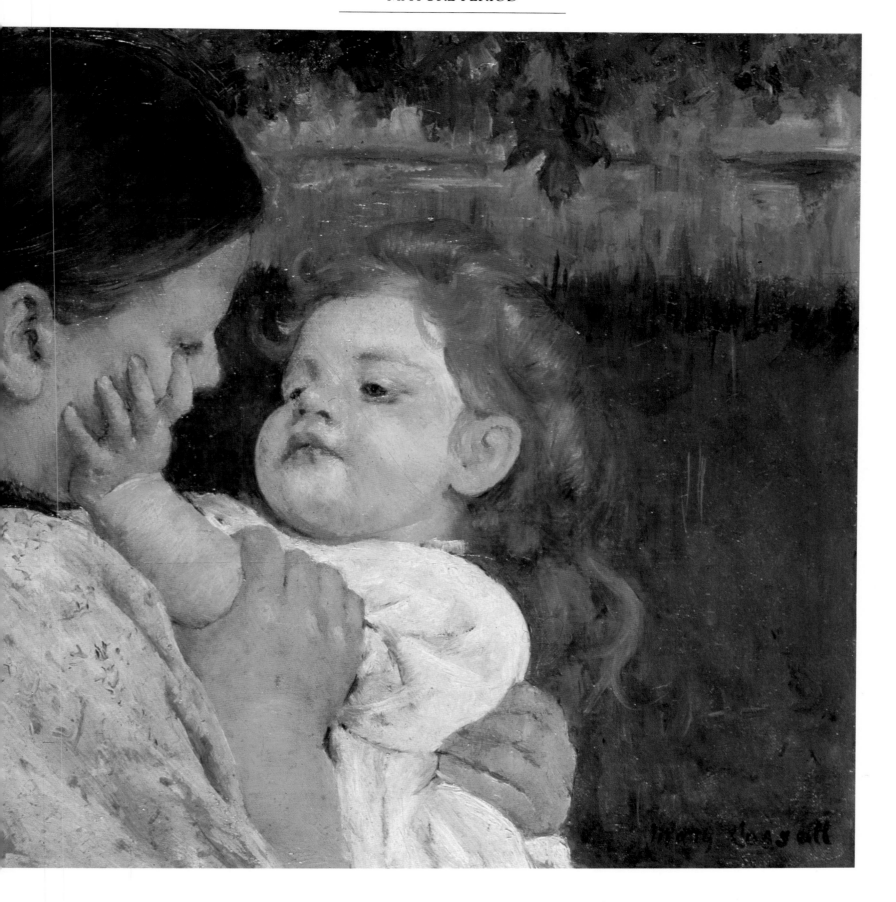

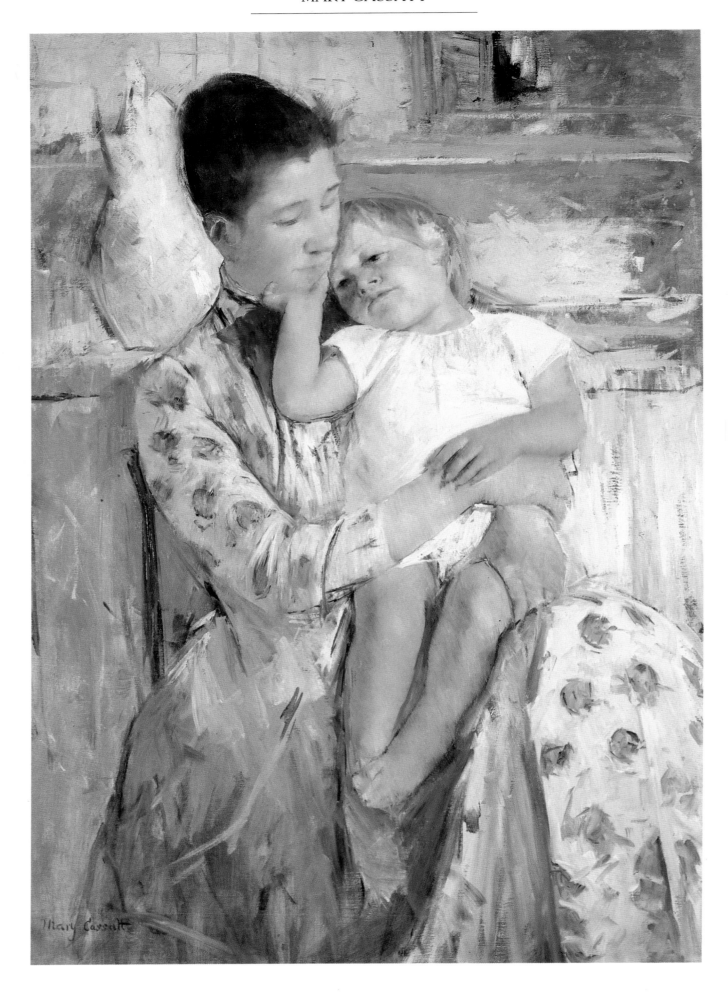

Mother and Child
c. 1890, oil on canvas, 35⅜×25⅜ in.
The Roland P. Murdock Collection,
Wichita Art Museum, KS
(M 109.53)

Young Girls
1897, pastel on paper mounted on linen,
25×20¾ in.
James E. Roberts Fund,
© *1989 Indianapolis Museum of Art, IN*
(25.287)

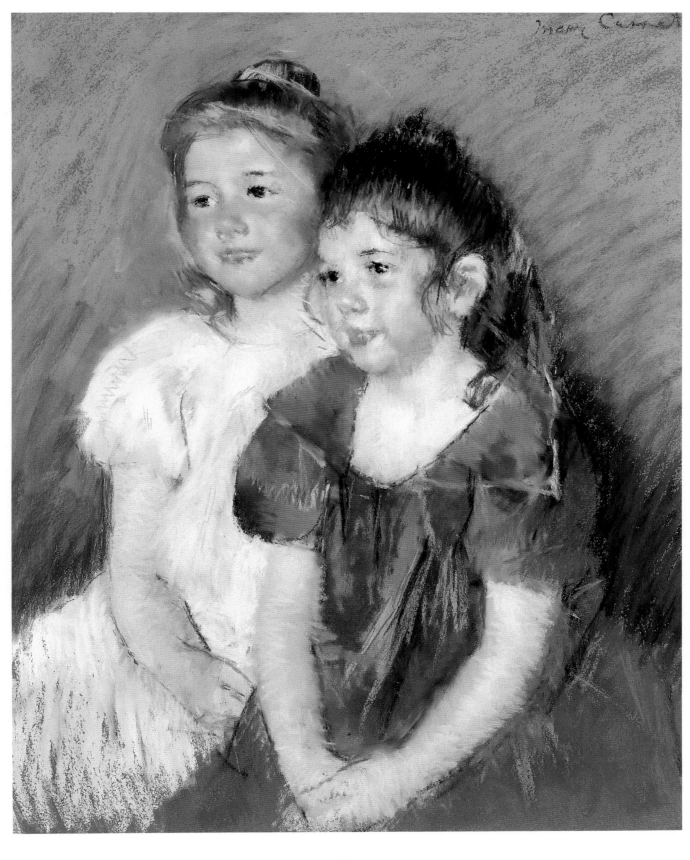

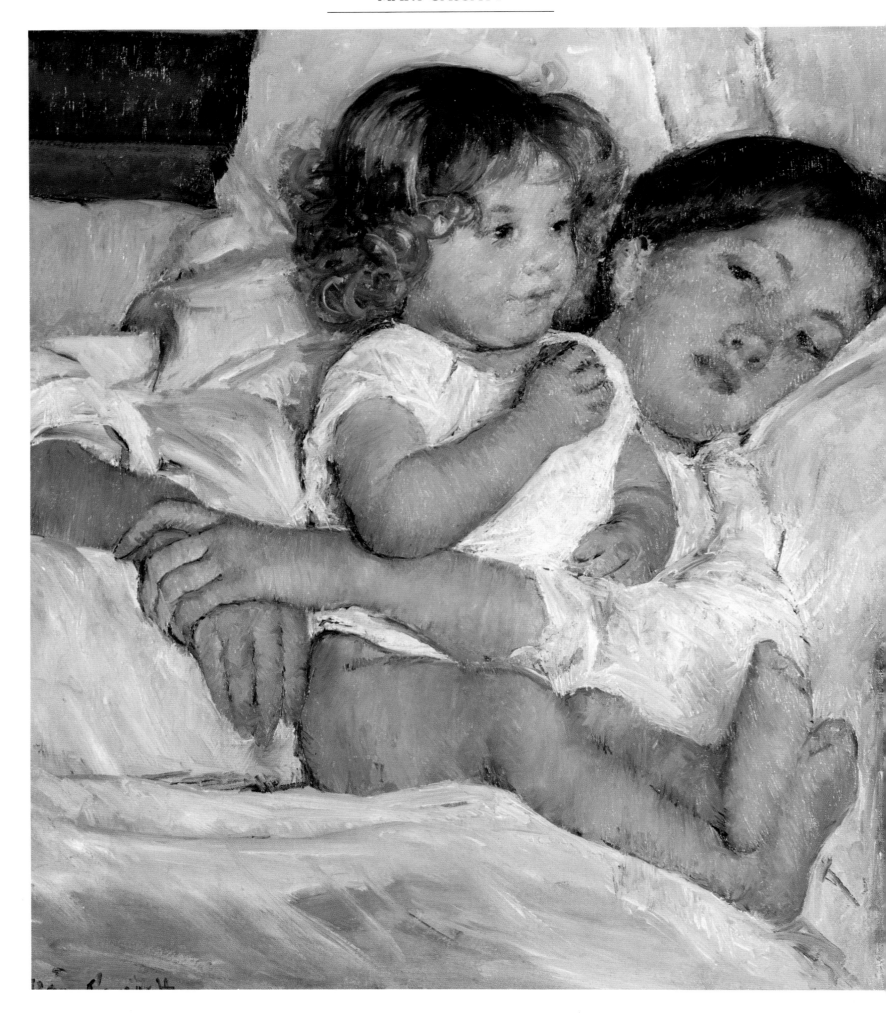

Breakfast in Bed
1897, oil on canvas, 23×29 in.
Virginia Steel Scott Collection,
Henry E. Huntington Library and Art
Gallery, San Marino, CA

Louisine W. Havemeyer
1896, pastel on paper, 29×24 in.
Courtesy of Shelburne Museum, VT

The Sailor Boy: Gardner Cassatt
1892, pastel on paper, 25×19 in.
Given by Mrs. Gardner Cassatt,
Philadelphia Museum of Art, PA
('61-175-1)

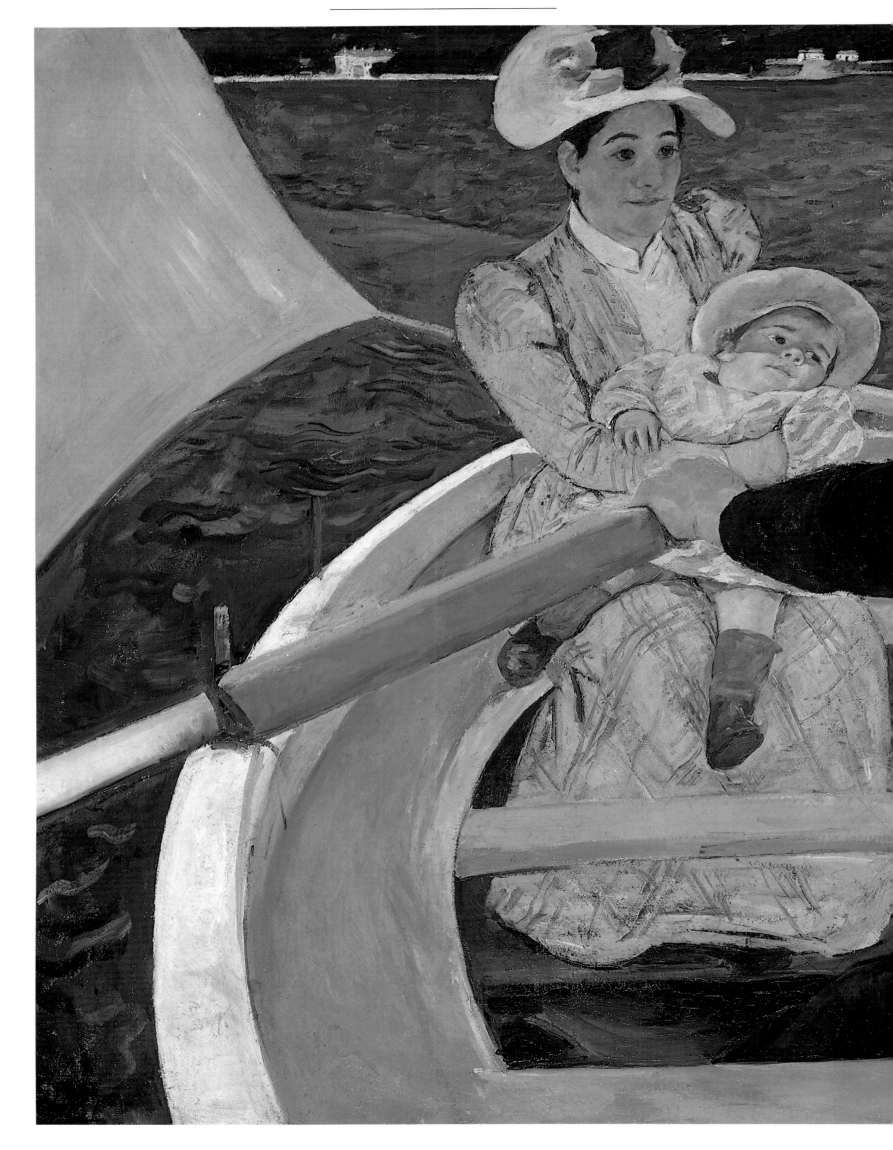

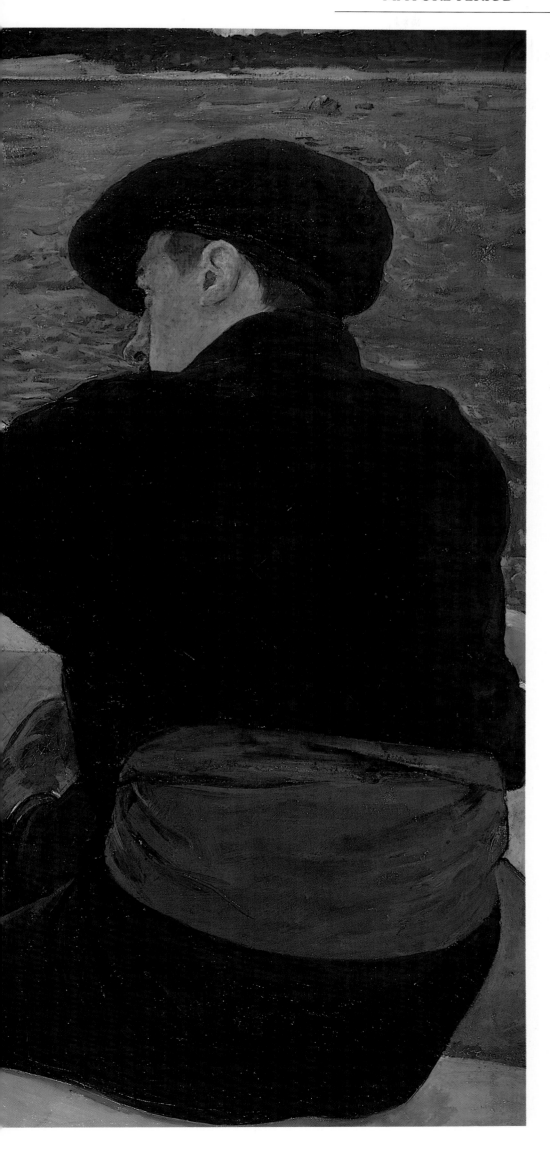

The Boating Party
1893-94, oil on canvas, 35½×46 in.
National Gallery of Art, Washington, DC

The Banjo Lesson
1894, pastel on paper, 28×22½ in.
*The Adolph D. and Wilkins C. Williams
Fund,*
*Virginia Museum of Fine Arts, Richmond,
VA*
(58.43)

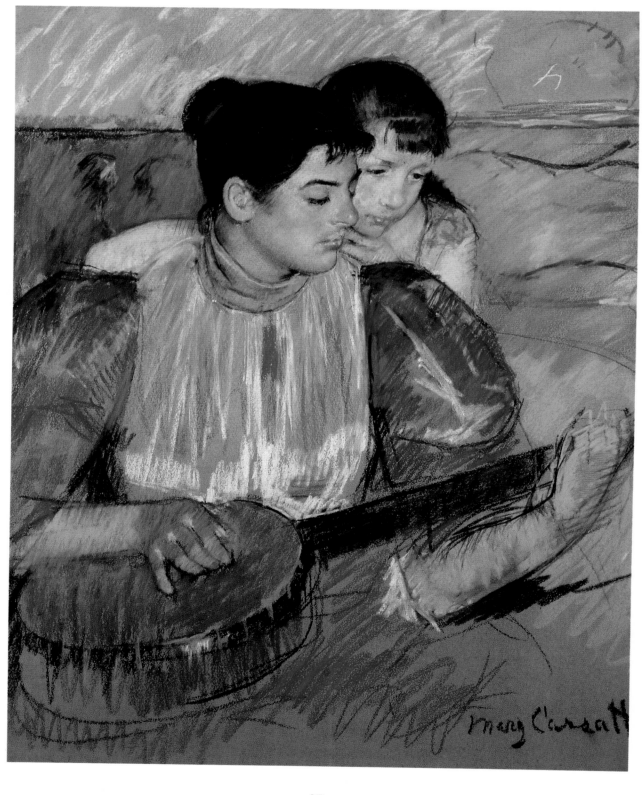

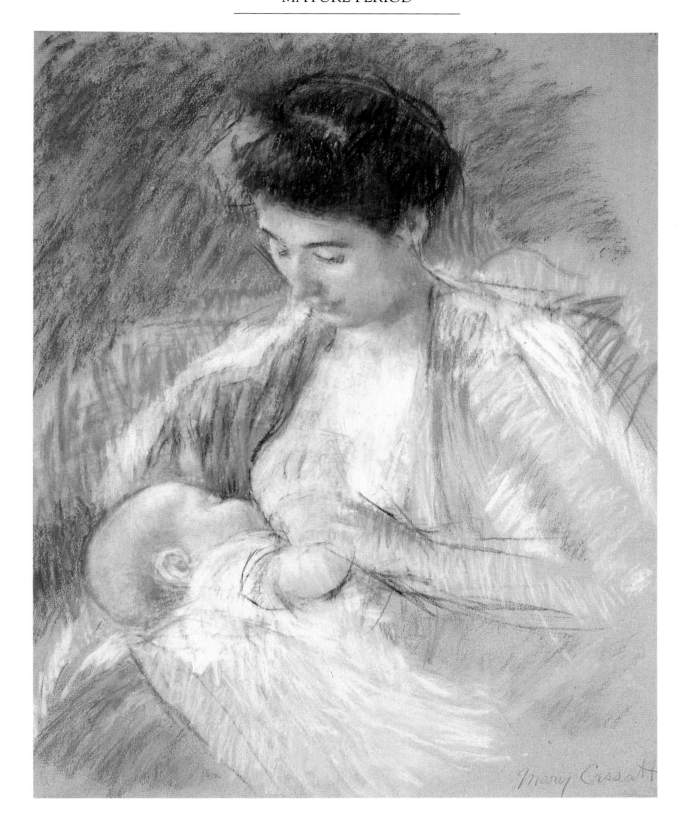

Mother Rose Nursing Her Child
c. 1900, pastel on paper, 28¼×22¾ in.
Courtesy of Shelburne Museum, VT

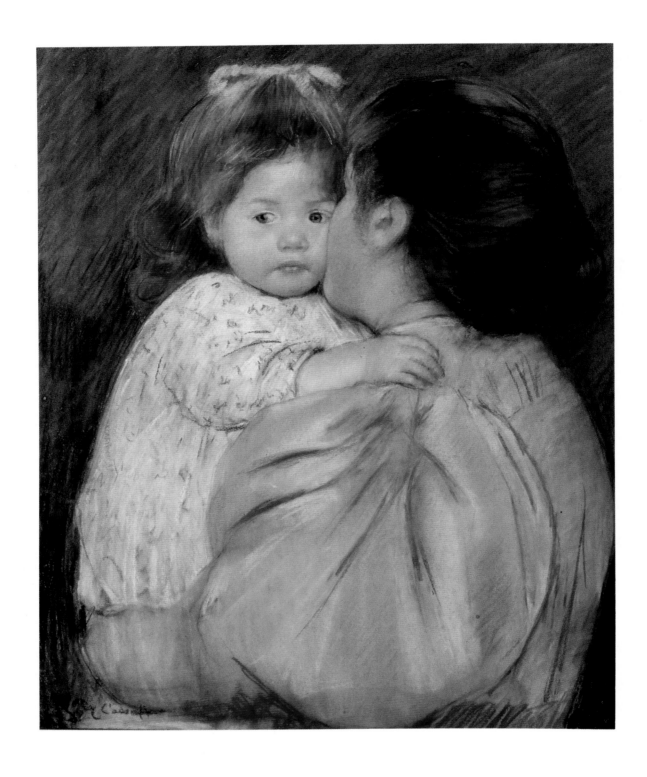

Maternal Kiss
1897, pastel on paper, 22×18½ in.
Bequest of Anne Hinchman,
Philadelphia Museum of Art, PA
('52-82-11)

Baby's First Caress
1891, pastel on paper, 30×24 in.
Harriet Russell Stanley Fund,
From the Collection of the New Britain
Museum of American Art, CT
Photo: E. Irving Blomstrann

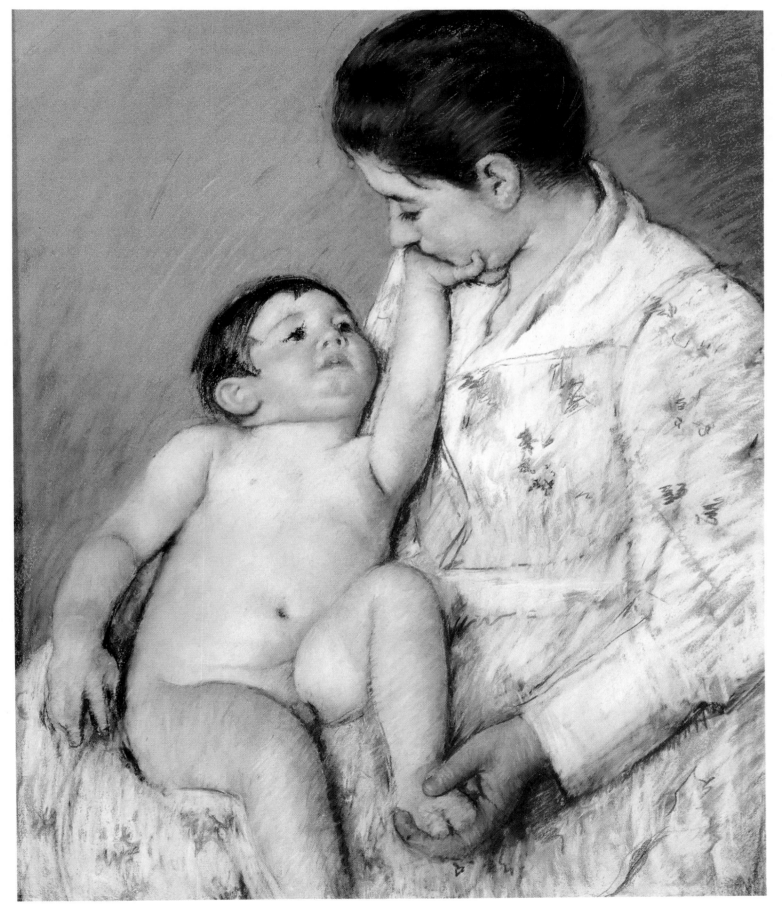

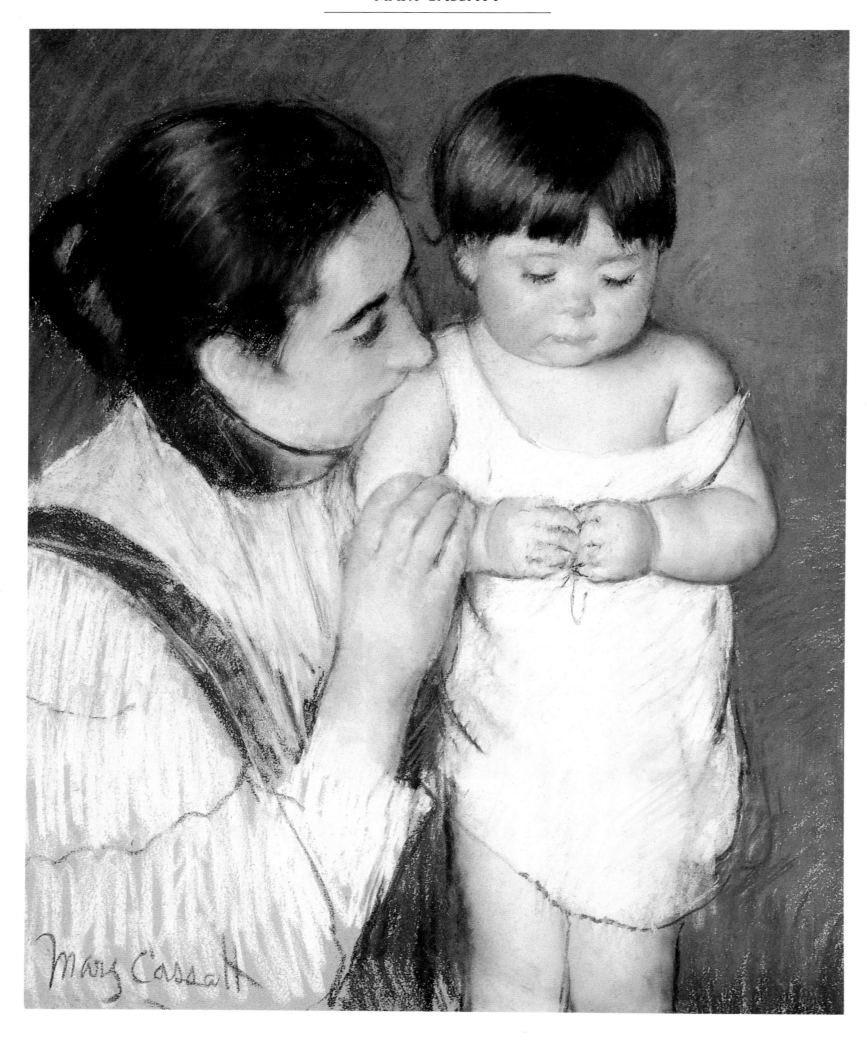

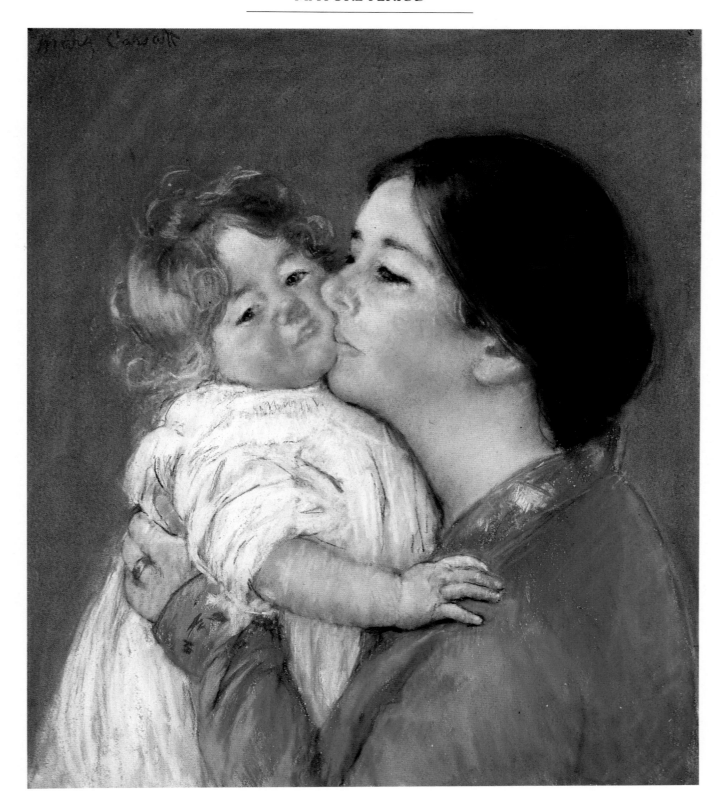

Left:
Young Thomas and His Mother
1893, pastel on woven paper, 23⅝×19¾
in.
Courtesy of the Pennsylvania Academy of the
Fine Arts Philadelphia, PA
(1904.10)

A Kiss for Baby Anne
c. 1897, pastel on paper, 21½×18¼ in.
The Helen and Abram Eisenberg Collection,
The Baltimore Museum of Art, MD
(BMA 1976.55.1)

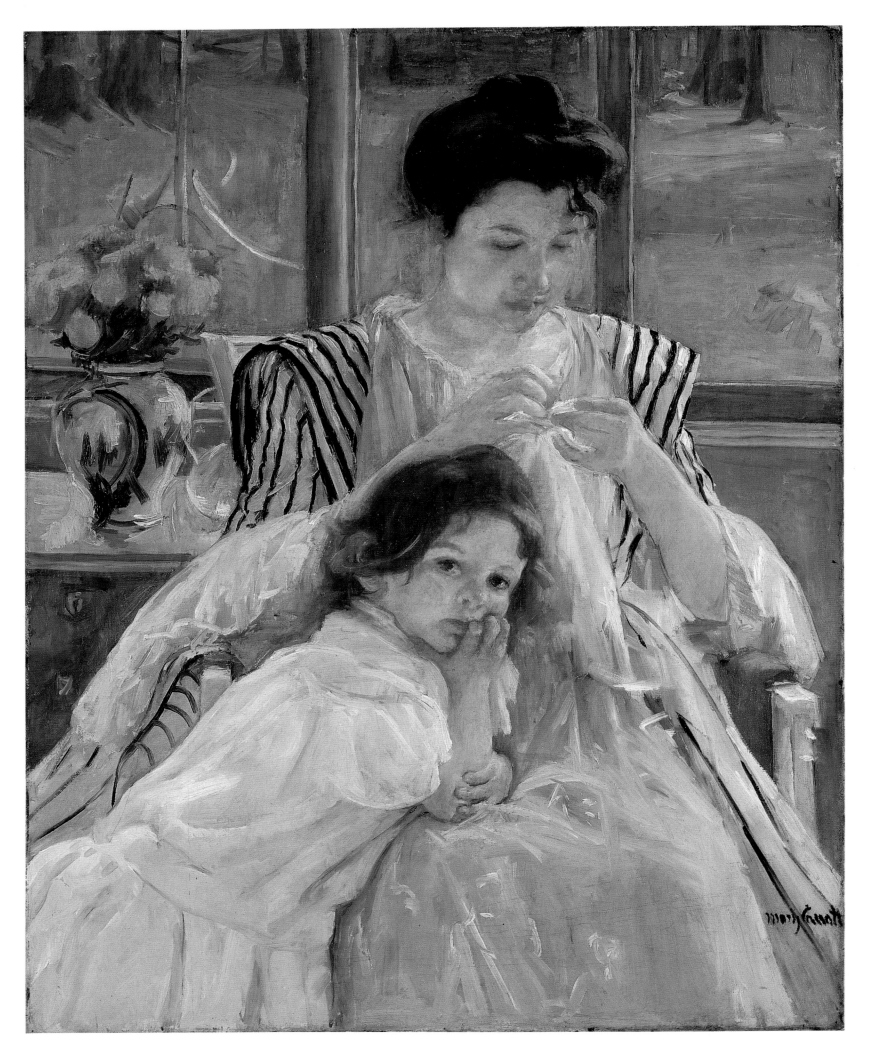

THE LATE
PERIOD

By the turn of the century Cassatt had acquired the status of a doyenne of the art world, and throughout her sixties she continued to produce remarkable work that further supported her position as the preeminent woman artist of the period. The recognition from the official art world, which she had so consistently renounced since her affiliation with the Impressionists, was heaped upon her willy-nilly, despite her refusal to accept any awards given by juries.

Many of her paintings from the early years of the twentieth century seem somehow grander and more finished than her earlier work. Part of this effect is the result of her return to the use of oil paints, now applied more heavily with longer, looser brush strokes than before. This can be seen in the *Young Mother Sewing* and *The Caress*, the painting for which Cassatt was offered two prestigious American awards. Her rendering of flesh tones is more traditionally graduated, ranging from the darkest browns in the backgrounds to the bright white highlights. She also manipulated space and proportion to make her figures appear larger and sometimes added mirrors, as in such paintings as *Mother and Child/The Oval Mirror* and *Mother Wearing a Sunflower on Her Dress*.

Cassatt worked extremely hard for the first ten years of the new century and produced a prodigious quantity of work. Occasionally, prompted by the growing demand for her paintings, Cassatt allowed unfinished work to leave her studio, resulting in a number of paintings that do not reflect the polish of her previous work. Also, perhaps because of the pressure under which she labored or because of the onset of eyesight problems, her attention to form became less precise. But at the same time she still managed to achieve wonderfully luminous effects in such oils as *Mother and Child* and *Mother and Child in a Boat* and such pastels as *Child in Orange Dress*.

By 1910 Cassatt's reputation in America was nearly at its zenith. Critics were showering her with praise not only for the aesthetic qualities of her work but for what they perceived as her mastery in conveying the psychological subtleties of her subjects' moods. But that same year her brother, Gardner, died, leaving her in a state of depression so acute that she produced virtually nothing for two years. Some of her later works such as *Young Woman in Green, Outdoors in the Sun*, suggest, with their unusually vivid use of color, that Cassatt's eyesight was now seriously failing. Although she was physically strong and mentally alert, her continuing problems with cataracts impaired her vision and, as the decade progressed her eyesight steadily worsened. Finally, in 1915, she had to abandon painting entirely.

But Cassatt never abandoned her art: she kept busy during the remaining years of her life making sure that her paintings were placed in the best collections. If she was trying to insure her place in history, she need not have worried. Her death in 1926 prompted newspapers of the day to report at length on her many achievements, and the article in the New York *Herald Tribune* summed up the sentiment felt by many. "It is hard to think of her as gone from the French environment. For years she had seemed one of the permanent figures of an epoch. It is as such, indeed, that she will long be remembered."

Young Mother Sewing
c. 1900, oil on canvas, 36⅜×29 in.
Bequest of Mrs. H.O. Havemeyer, 1929,
The H.O. Havemeyer Collection,
The Metropolitan Museum of Art, New
York, NY
(29.100.48)

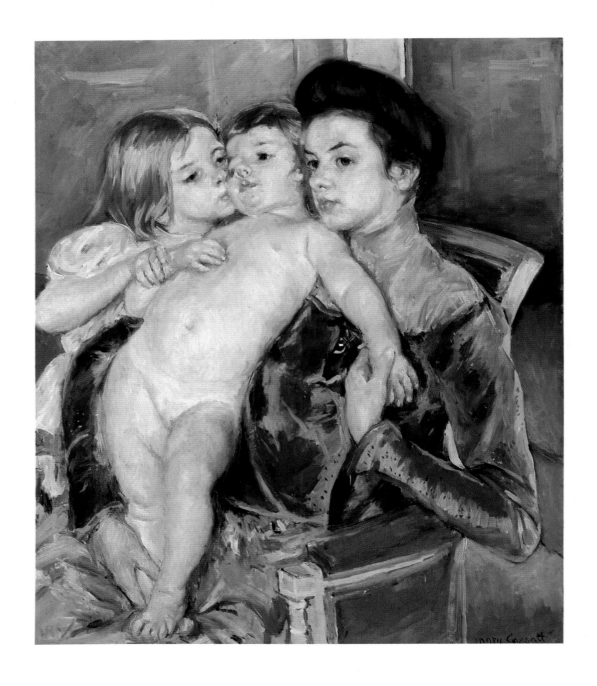

The Caress
1902, oil on canvas, 32⅞×27⅜ in.
Gift of William T. Evans,
National Museum of American Art,
Smithsonian Institution, Washington, DC
(1911.2.1)

Right:
Mother Wearing a Sunflower on Her Dress
c. 1905, oil on canvas, 36¼× 29 in.
Chester Dale Collection
National Gallery of Art, Washington, DC

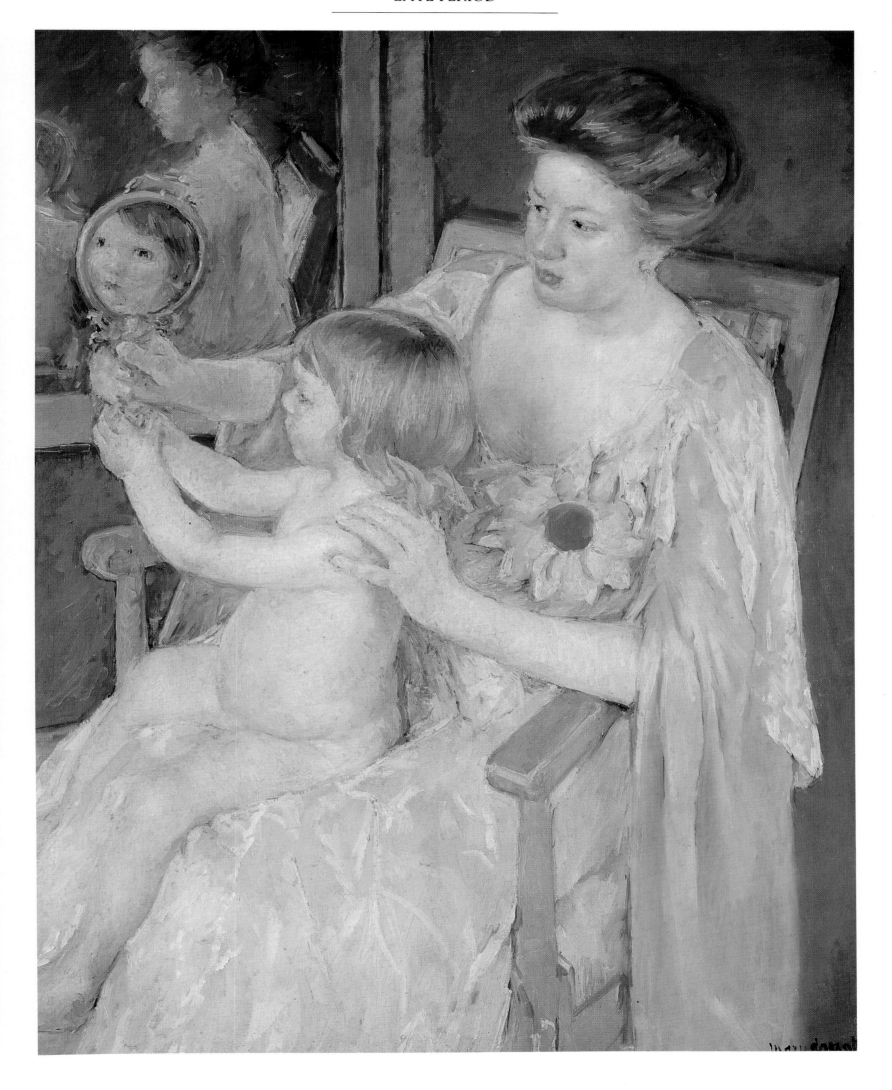

Woman and Children
1906, oil on canvas, 29¼×36¼ in.
Gift of Dr. Ernest G. Stillman,
Courtesy of The Fogg Art Museum, Harvard
University, Cambridge, MA
(1922.28)

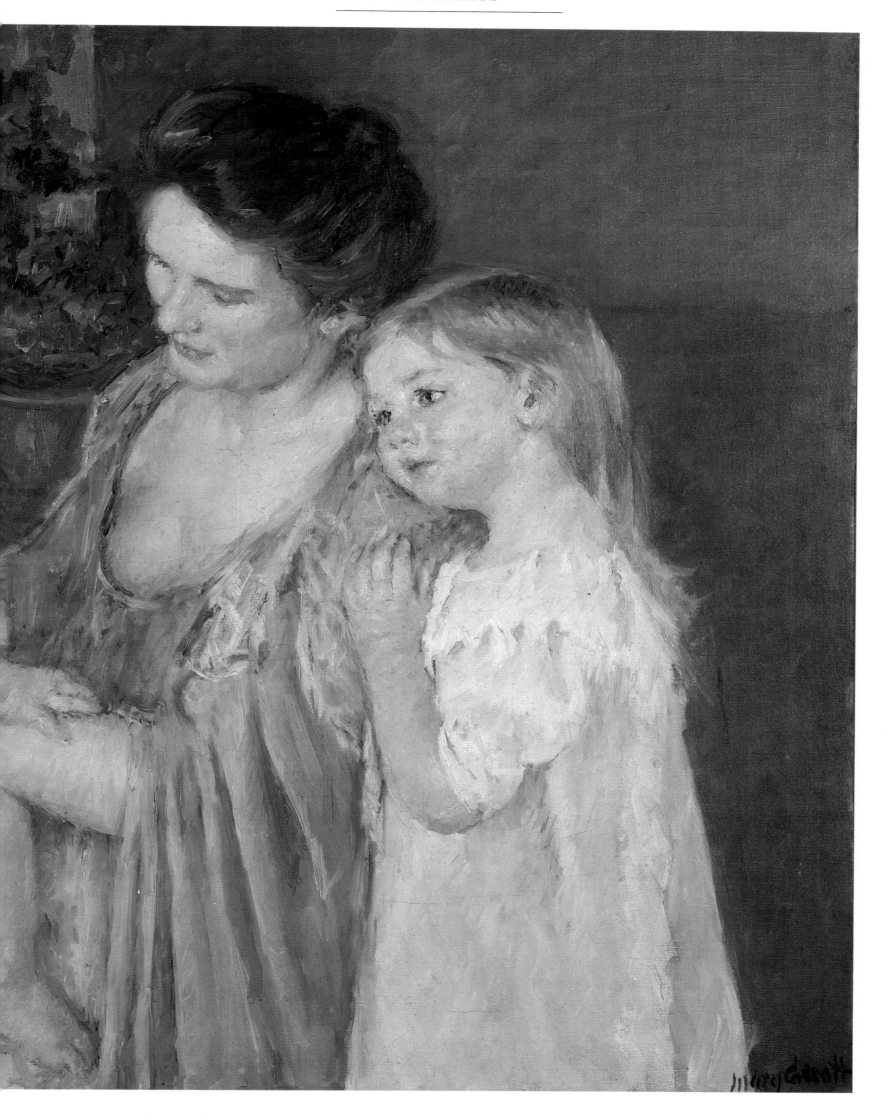

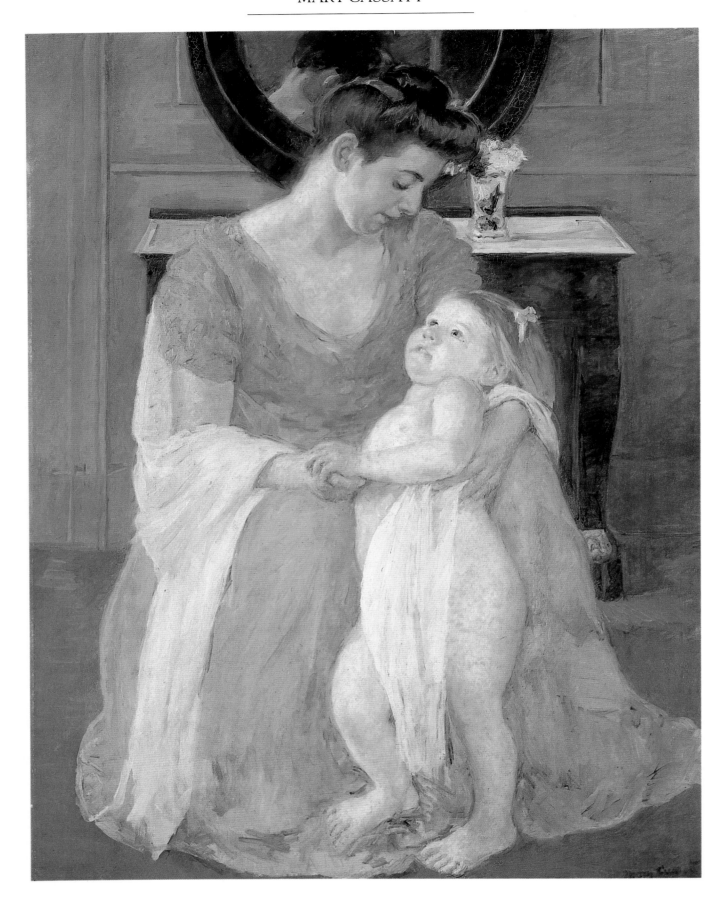

Mother and Child
1908, oil on canvas, 46×35½ in.
Bequest of Miss Adelaide Milton de Groot
(1876-1967), 1967,
The Metropolitan Museum of Art, New
York, NY

Fillette au Grand Chapeau
c. 1908, pastel on buff paper, 25¼×19½
in.
Henry E. Huntington Library and Art
Gallery, San Marino, CA

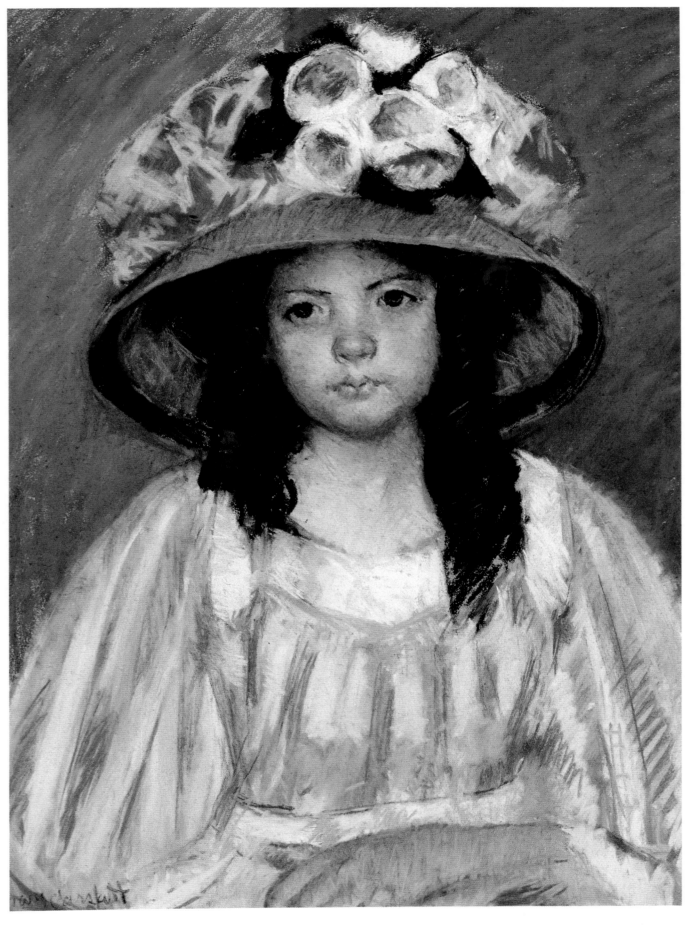

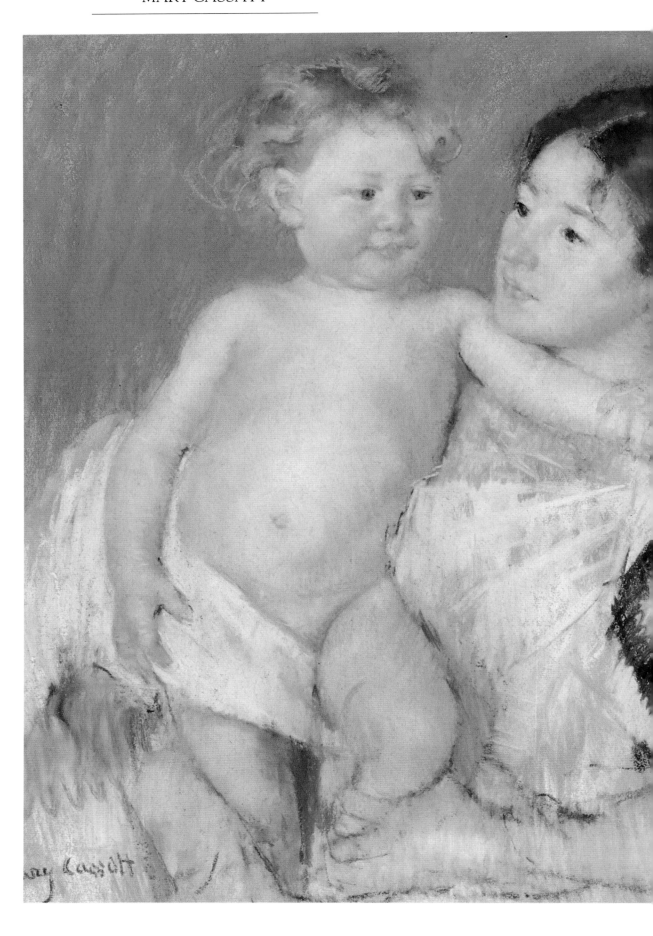

After the Bath
1901, pastel, 25⅗×39¼ in.
Gift of J.H. Wade,
The Cleveland Museum of Art, OH
(20.379)

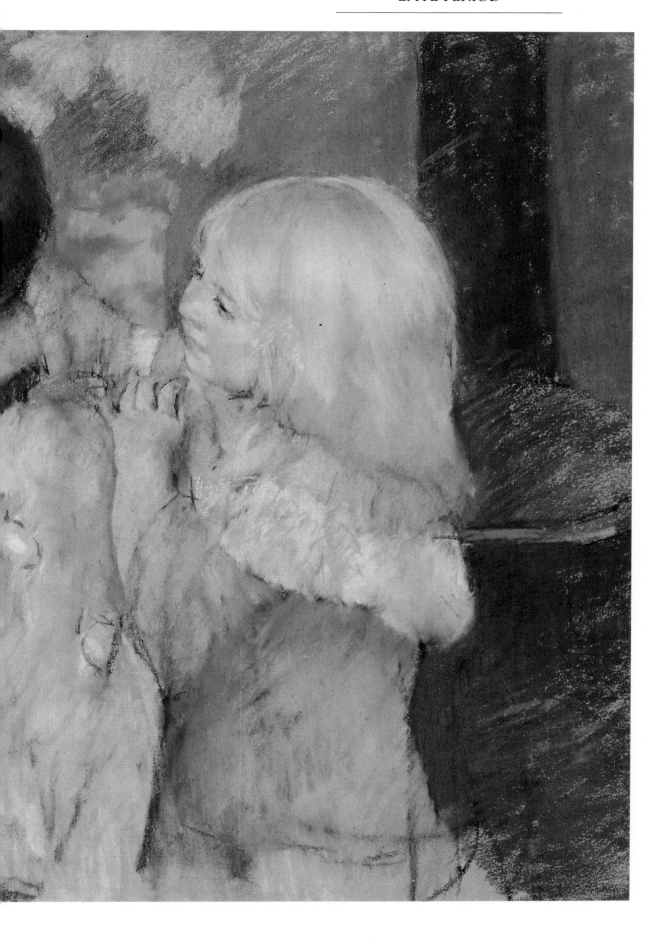

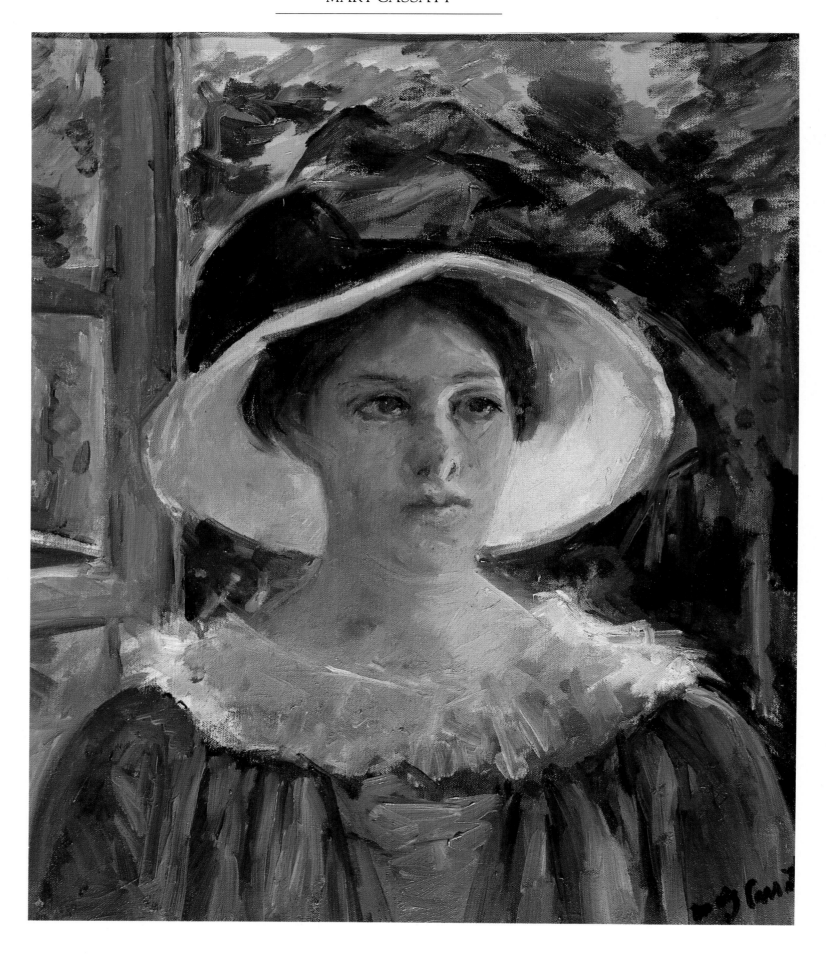

**Young Woman in Green, Outdoors in
the Sun**
1914, oil on canvas, 21¹¹/₁₆ × 18¼ in.
Gift of Dr. Ernest G. Stillman,
Worcester Art Museum, MA
(1922.12)

Right:
Mother and Child in a Boat
c. 1909, oil on canvas, 45½ × 32 in.
*Addison Gallery of American Art, Phillips
Academy, Andover, MA*

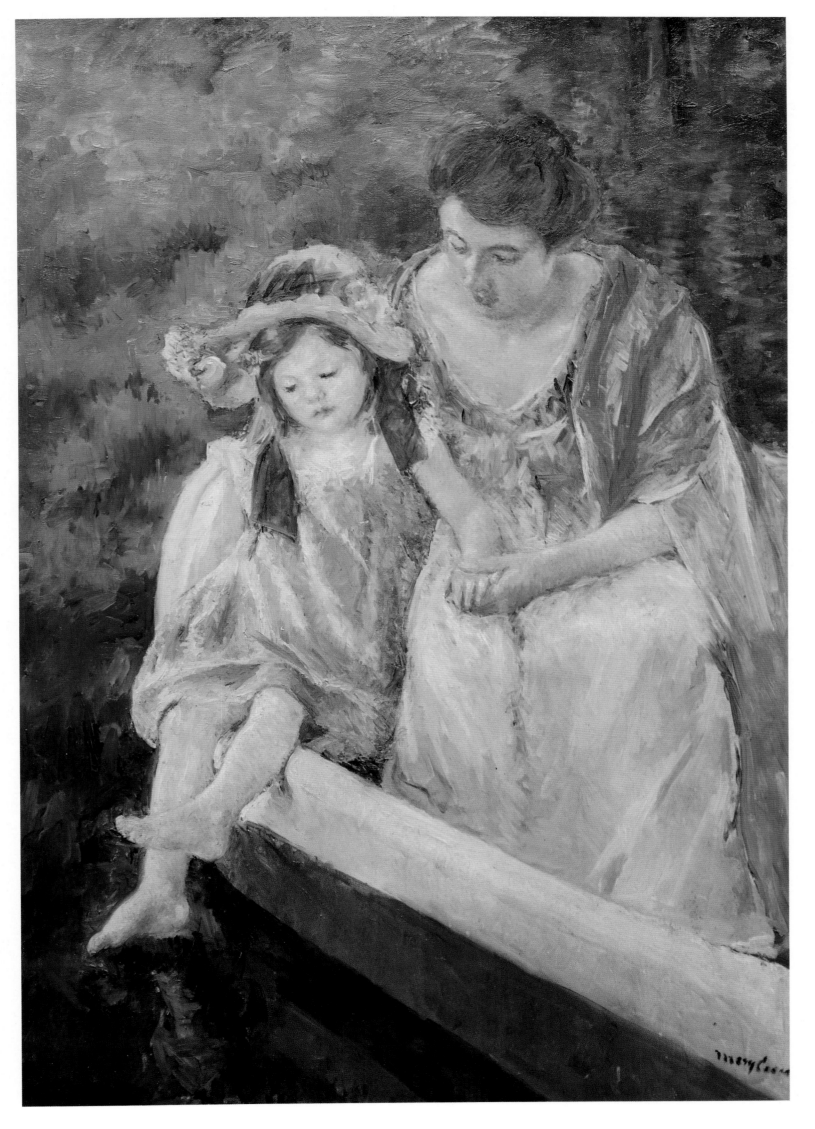

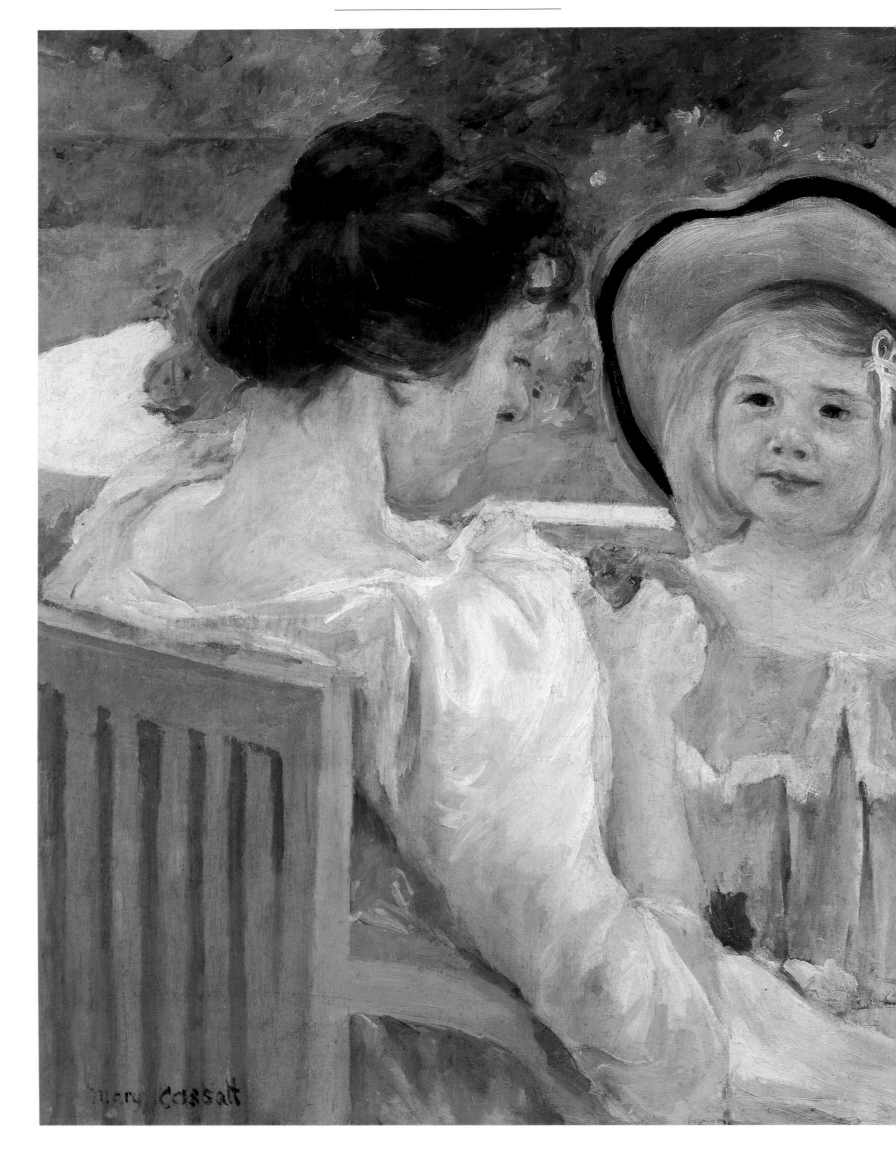

In the Garden
1904, oil on canvas, 26¾×32½ in.
Gift of Dr. Ernest G. Stillman,
© *The Detroit Institute of Arts, MI*
(22.6)

Child in Orange Dress
1902, pastel on light brown woven paper,
28⅝×23⅝ in.
From the Collection of James Stillman, Gift
of Dr. Ernest G. Stillman, 1922,
The Metropolitan Museum of Art, New
York, NY
(22.16.25)

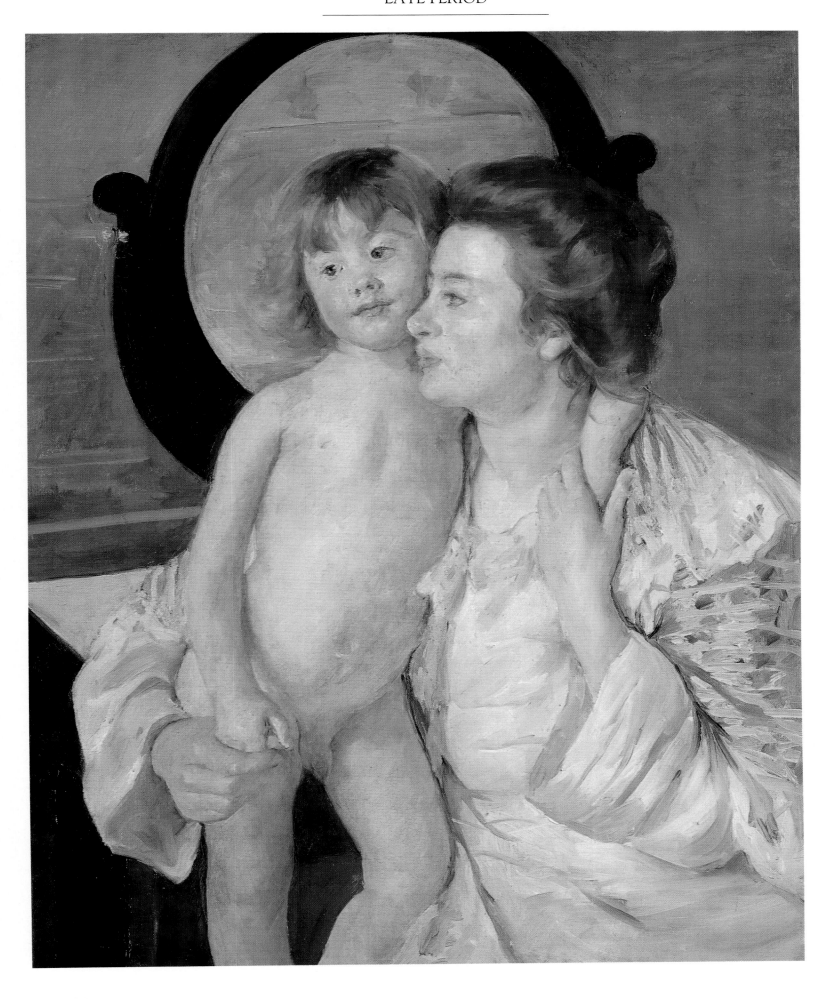

Mother and Child (The Oval Mirror)
1901, oil on canvas, 32⅛×25⅞ in.
Bequest of Mrs. H.O. Havemeyer, 1929,
The H.O. Havemeyer Collection,
The Metropolitan Museum of Art, New
York, NY
(29.100.47)

Mother Combing Her Child's Hair
c. 1901, pastel and gouache on tan paper,
25¼×31⅗ in.
Bequest of Mary T. Cockcroft,
The Brooklyn Museum, NY
(46.102)

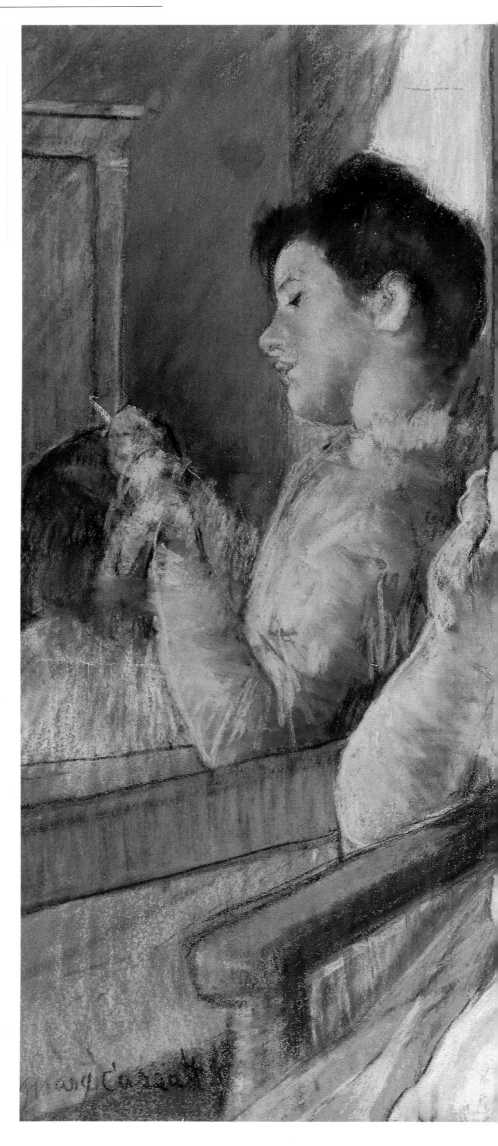

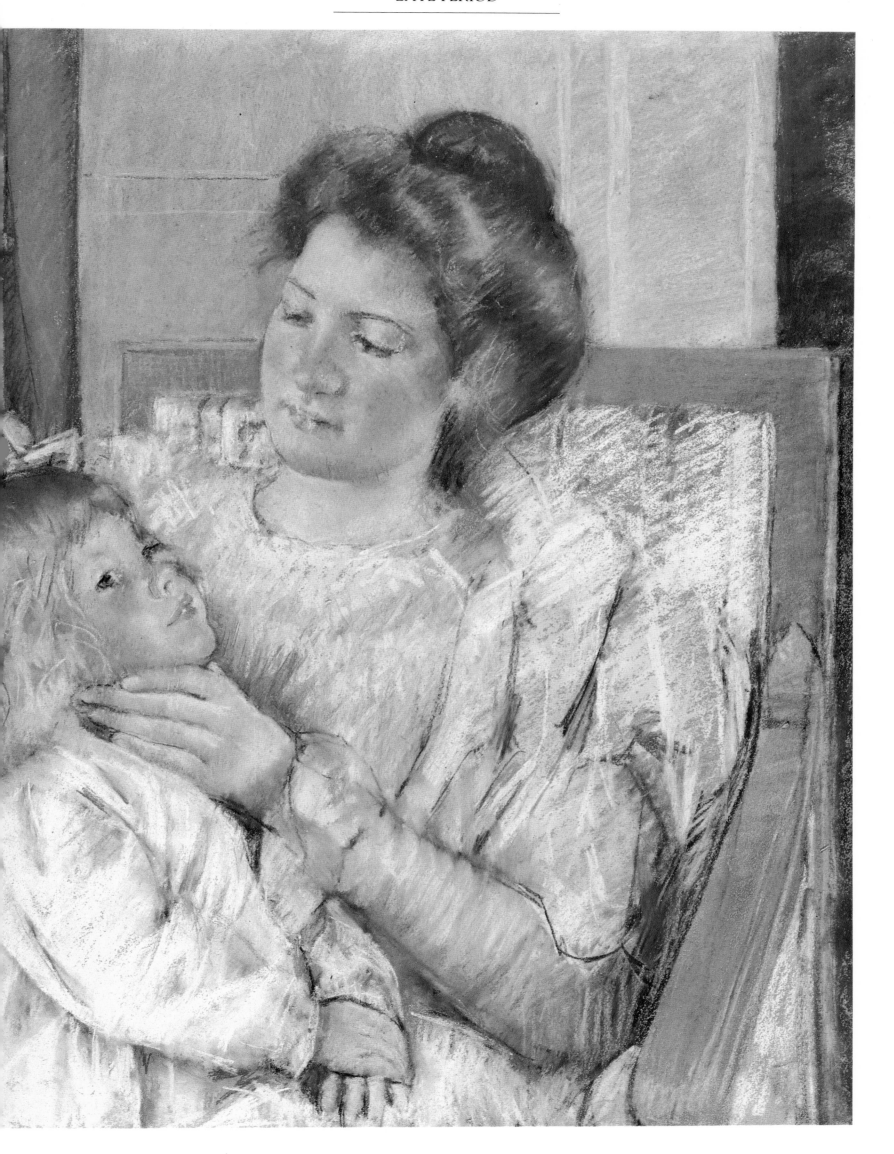

LIST OF COLOR PLATES

After the Bath	102-103	Maternal Kiss	90
At the Opera	47	Mr. Robert Cassatt on Horseback	6
At the Theater	50	Mother About to Wash her Sleepy Child	30
Baby Reaching for an Apple	77	Mother and Child (1889)	45
Baby's First Caress	91	Mother and Child (c. 1890)	80
The Banjo Lesson	88	Mother and Child (The Oval Mirror)	109
The Boating Party	86-87	Mother and Child (1908)	100
The Barefooted Child	58	Mother and Child in a Boat	105
The Bath (c. 1891)	54	Mother Combing her Child's Hair	110-111
The Bath (c. 1891-92)	2	Mother Feeding Her Child	74-5
Breakfast in Bed	82-83	Mother Rose Nursing Her Child	89
By the Pond	64-65	Mother's Kiss	66
The Caress	96	Mother Wearing a Sunflower on her Dress	97
Child in an Orange Dress	108	Nurse and Child	69
Child in a Straw Hat	42	Nurse Reading to a Little Girl	60-61
Children Playing on a Beach	39	On the Balcony, During Carnival	24
Ellen Mary Cassatt in a White Coat	68	Portrait of Alexander Cassatt	46
The Family	72	Portrait of an Elderly Lady	44
Family Group Reading (A Garden Lecture)	4-5	Portrait of a Woman	22
Fillette au Grand Chapeau	101	Portrait of a Young Girl	73
The Fitting	63	Portrait of Mr. Alexander J. Cassatt and His Son	1
Five O'Clock Tea	36-37	Portrait of the Artist	26
Girl Arranging Her Hair	43	The Sailor Boy: Gardner Cassatt	85
In the Garden (1893)	67	Spanish Dancer Wearing a Lace Mantilla	23
In the Garden (1904)	106-107	Susan Comforting a Baby No. 1	48-49
In the Loge	28-29	Woman and Child Driving	52-53
In the Omnibus	57	Woman and Children	98-99
La Jeune Mariée	25	Women Arranging Her Veil	51
A Kiss for Baby Anne	93	Woman Reading in the Garden	34
Lady at the Tea Table	38	Woman with a Pearl Necklace in a Loge	35
The Lamp	56	Woman with a Red Zinnia	59
The Letter	62	Women Admiring a Child	70-71
Little Girl in Blue Armchair	32-33	Young Girls	81
The Loge	31	Young Mother Sewing	95
Louisine W. Havemeyer	84	Young Thomas and His Mother	92
Lydia at a Tapestry Frame	40-41	Young Woman in Green, Outdoors in the Sun	104
The Mandolin Player	20	Young Women Picking Fruit	76
Maternal Caress	78-79		

Picture Credits

All pictures were provided by the credited museum or gallery, except for those supplied by the following:
Art Institute of Chicago (Gift of Walter S. Brewster): page 14(bottom)
The Bettmann Archive, New York, NY: pages 9, 17, 18
The Metropolitan Museum of Art, New York (Bequest of William H. Walker): page 16
Musée d'Orsay, Musées Nationaux, Paris, France (© DACS 1988): page 10
Musée d'Orsay, Paris, France/The Bridgeman Art Library, Lauros-Giraudon: page 12
Museum of Fine Arts, Boston (Purchase Fund 1931): page 14(top)
Parma Cathedral: page 11(top)
Pennsylvania Academy of Fine Arts, Archives, Philadelphia, PA: pages 7(top), 8(top)

Pennsylvania Academy of Fine Arts, Philadelphia, PA (Gift of John Frederick Lewis): page 11(bottom)
Philadelphia Museum of Art, PA (Given by Charles P. Davis and Gardner Cassatt in Memory of Mary Cassatt): page 18
Private Collections: 7(bottom; print supplied by Phaidon Press), 8(bottom)
The Wadsworth Athenaeum, Hartford (Bequest of Anne Parrish Titzell): page 15

Acknowledgments

The publisher would like to thank the following who helped in the preparation of this book: Don Longabucco, who designed it; Dianne Dailey, who did the picture research; and John Kirk, who edited the text.